SCOTTISH WATERCOLOUR PAINTING

SCOTTISH WATERCOLOUR PAINTING

JACK FIRTH, RSW

THE RAMSAY HEAD PRESS EDINBURGH

First published in 1979 by
The Ramsay Head Press
36 North Castle Street
Edinburgh EH2 3BN

Printed by Macdonald Printers (Edinburgh) Limited
Edgefield Road, Loanhead, Midlothian

ISBN 0 902859 58 7

Contents

Illustrations

Note: *Measurements are in inches, height preceding width*

Acknowledgements

When one has written a book the truth of the saying that no man is an island becomes only too clear. Indebtedness proliferates. This is a book about painters past and present who constitute the dramatis personae and it is therefore to all of them that I am primarily indebted. Many of them, directly or indirectly, taught me about painting; all of them have given me something worthwhile to write about. To the living artists my thanks are due for their friendly help, particularly with illustrations. I am also most grateful to the owners of pictures who have co-operated; to Aberdeen Art Gallery and to Edinburgh City Art Centre for help in obtaining photographs and to them as well as The Scottish Arts Club and Lothian Region Department of Education for permission to reproduce paintings. I am grateful also to Bill Jackson of Aitken Dott's for his personal help, to Bill Brady who took many of the photographs in colour, and lastly to Norman Wilson of the Ramsay Head Press without whose enthusiasm the book would probably never have happened.

Jack Firth

Introduction

The idea for this book arose out of a long-standing personal involvement with watercolour painting and painters and also partly as a result of some lectures which I had given on the subject. I became more and more convinced that in Scotland there is something very like a national "school" of watercolour which exists here in a way that does not happen elsewhere and which has become more important during the last thirty years than it has ever been. Scottish painters working in this medium have had the ability to extend its limits and to create a thoroughly twentieth century art form which is practised at an unrivalled level of concentration.

This seems a good reason to write about Scottish watercolour and as there is as yet no other book on the subject there might conceivably be a need for such a statement. The Royal Scottish Society of Painters in Water-Colours celebrates its hundredth exhibition in 1980 and this book is concerned with watercolour painting of the present day and with those artists whose work and vision made it possible to create a climate of painting in which watercolour could develop. It does not set out to be a history and is certainly not intended to be in any way definitive regarding its selections of artists, but it is hoped that by examining the achievements of some of the key-figures whose work holds such a potential for excitement they may be paid a timely tribute.

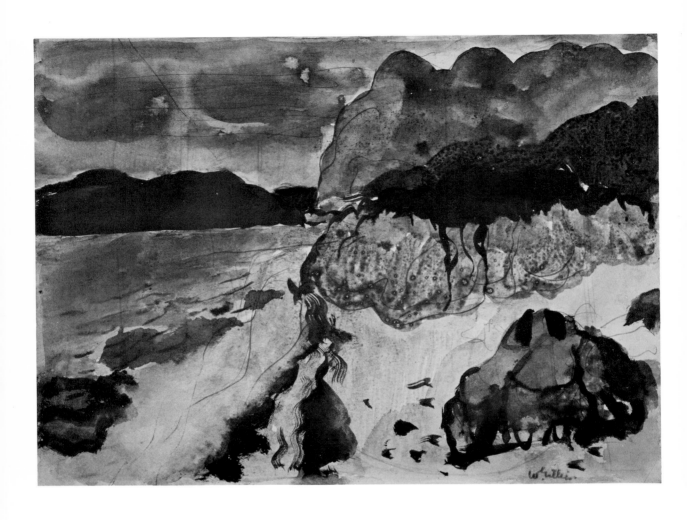

1. SIR WILLIAM GILLIES CBE RSA RA P/PRSW *Morar 1928* 7 × 9
 Private Collection

1

About Watercolour

WATERCOLOUR painting has been with us for a long time. It occurred in ancient art, in medieval painting, in illuminated illustrations and the decorated capital letters in manuscripts, in miniatures and in various other forms of art before the day of the "easel picture". This brief account is not concerned with those forms, nor is it appropriate to dwell on the exquisite schools of watercolour to be found in the Far East. We are here concerned with the origins of the medium in Western painting and in this, watercolour began as a tool for on-the-spot recording, an adjunct to the artist's technical repertoire. The paraphernalia of other media rendered them unsuitable for painting *sur le motif* and everyone who has seen Turner's painting equipment in its glass case in the Tate Gallery can see the difficulties experienced by an artist trying to work away from his studio.

With a few intrepid exceptions, artists could not cope with the problem of making up freshly-ground, semi-liquid oil paint, spooned into small animal bladders for transportation out of doors. Pigment in the raw state came then as it does still, in the form of powders, crystals, lumps, granules and vegetable or animal matter of various kinds. This had to be ground with the oil medium to make it tractable. Watercolour on the other hand could be made by mixing the same pigments with an aqueous solution of gum which formed it into a paste. This was dried out in slabs, cut up into small pieces and could be carried easily in a box or even in the pocket. When moistened, the paint was ready to be applied with a "pencil", as brushes were traditionally termed. On occasion the paint solution was taken up on small pieces of fabric which could readily be carried and which when moistened yielded the paint to the brush.

The support for watercolour is also simple and light to carry about, being sheets of paper instead of wood panels or canvases. It is also worth noting that the whole tradition of painting landscapes tended to proceed according to a time-honoured convention and formula. The picture was gradually built up in stages, distance being rendered by a system of working from cool and pale colours in the distance through stronger and warmer colours in the middle distance to still warmer and darker foreground passages. While all the information in the picture was based, either directly or at second hand upon study from nature in sketchbook drawings, the aim of landscape painting from the Flemish and Italian painters of the fifteenth century onwards was to recreate the landscape according to this process. So landscape study was, for convenience, confined to watercolour or purely graphic materials, while oil painting with all its chemistry and what has been called its "cuisine" was executed in the studio.

In the sixteenth century Dürer painted beautifully fresh watercolours on his extensive travels, recording impressions of places and studying detail for subsequent use in major works. Sometimes these paintings stand in their own right as complete statements. The best-known of them, *The House by the Pond* in the British Museum, *The Large Piece of Turf* in the Albertina or the brilliant little *View of Trento* in the Kunsthalle at Bremen, are masterpieces by any standards. Artists of the seventeenth and eighteenth centuries such as Rubens, Van Dyck, many of the Dutch and German painters and, of course, the whole national school of English watercolour, esablished the medium as acceptable for landscape work but without the prestige of oil painting. In the main, watercolour studies of this type exhibit a reticence and a marked respect for the more delicate, transparent properties of the medium, in which the chief attribute is a deft immediacy.

In the 1830s the American invention of the roll-up tin tube — by an artist called Rand — made it possible to take oil colours outside, although there were many teething troubles concerned with attaining an airtight cap. About the same time the painter Daguerre, along with several other coincidental inventors, discovered photography. Winsor and Newton adopted the collapsible tin tube in 1841, while Daguerre's discovery was bought by the French government and made available to the public by 1839.

These two discoveries changed the course of painting — the one by sending artists out of doors with this new tool, the other by scaring them into trying to outdo photography's swift automatic effects. Many artists of the time thought that the camera would put them out of business, but it was to be a source of new ideas also. From the two events the great golden age of nineteenth century landscape derived much of its technological impetus. The inspiration, by contrast, came from literature and the Romantic attitude towards nature.

Watercolour societies were a defence mechanism. Since the beginning of the nineteenth century watercolour painters had been upstaged by the weightier practitioners in oils. From the inception of the large public exhibitions, watercolour because of its scale, its delicacy and its traditional reticence of effect, had been relegated to inferior hanging places. That could mean, in the crowded, many-tiered hanging arrangements of the time, somewhere near the ceiling. Breakaways of watercolour artists followed, first in England in 1804-05 with the inauguration of the Old Watercolour Society, and much later in Scotland when the Royal Scottish Society of Painters in Water-Colours was founded in 1878. Both societies aimed at displaying works on paper in more favourable circumstances than were available in the Academies. Other watercolour exhibiting societies sprang up. The New Society of Painters in Miniatures and Water-colours was founded in 1807 and the following year The Associated Artists in Water-colours, while in 1831 The Royal Institute of Painters in Water-colours was formed. The separate exhibitions met with general public approval. After all, watercolours are, on average, smaller than oils, cost less and — in the past — were quieter and more intimate in a domestic setting.

14

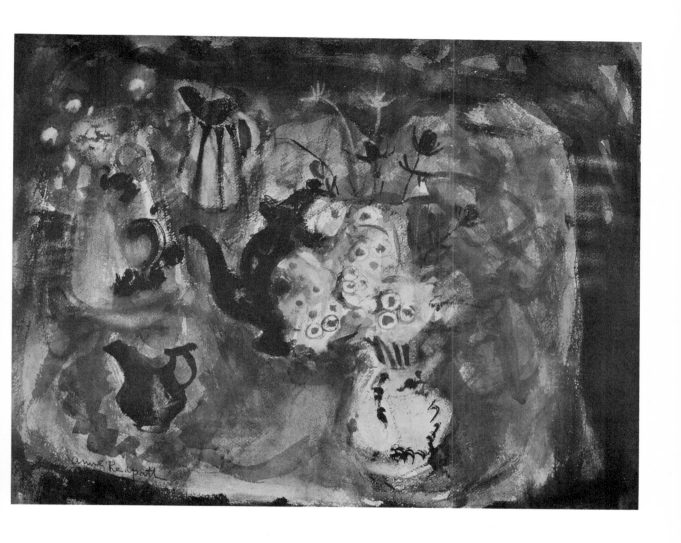

2. **ANNE REDPATH OBE RSA ARA** *Teapot and Flowers 1963* 22½ × 25½
Private Collection

During the rest of the century the medium continued its recording role and watercolourists painted favourite views, portraits of country seats and picturesque villages and towns and generally provided a kind of reportage. This was especially true when artists accompanied archaeological or exploratory expeditions abroad, of which there were very many during the century. It also continued as a preparatory medium for oil paintings, although it showed more and more that it was itself capable of producing important works in its own right. The legendary English artists such as Sandby, De Wint, Malton, Shotter Boys, Rowlandson, Wheatley, Towne, Cotman and Girtin became the English mainstream. Other artists could execute miracles of virtuosity of a heavier kind which sometimes looked like an attempt to emulate oils, even to the final coat of varnish in certain cases. The Pre-Raphaelite watercolours of the middle years of the eighteen hundreds, despite their occasional opacity, achieved a jewel-like quality, as did the oils by those artists, but it is all too easy to render watercolour dead by overworking it.

Then of course there was Turner, the great original, held in some veneration by artists of his own day, although it is doubtful whether his most adventurous and daring experiments in watercolour had emerged from his studio — many hundreds were to remain buried in the Turner archive for a long time after his death, and one also wonders how many were destroyed during Ruskin's evaluation of the oeuvre. Most certainly, Turner pushed the previously accepted limits of water colour further than any other artist up till his time. Setting new limits to the range of painting expression has always been the prerogative of men of genius. Turner used a bewildering range of technical methods of great originality and even eccentricity to achieve his ends.

In a different way, but no less original and decidedly more eccentric, Blake's paintings also extended the medium of watercolour, sometimes combining with printmaking. For an artist with no formal training in the accepted sense, whose drawing was learned mostly by copying monumental tomb sculpture in Westminster Abbey and by studying the figure from engravings after Raphael and Michelangelo, Blake could produce work of staggering power, albeit on a small scale. His art owes practically nothing to the world of direct observation and natural appearances, every picture being totally formed in his mind. Samuel Palmer's tiny gems also explored new territory in watercolour and for their scale carried much more impact and power than other work of the period. His fat lines weave across the paper to delineate the fecund shapes of ancient trees, leafy lanes, corn stooks and sheep but then his dense browns seem to fuse with the quill line so that drawing and painting are inseperable. He used body-colour and often varnished the painting, but in his case the inclusion of varnish seems somehow to enhance the feeling that his small pieces of paper have become magically transformed, like Paul Klee's mysterious fragments, into objects containing within themselves the timeless inevitability of icons, or tomb images from Egypt or Babylon or Mexico. Meanwhile, there was the great mass of traditional and conservative painting, often very competent and skilled, but truly original talents always stand out like milestones.

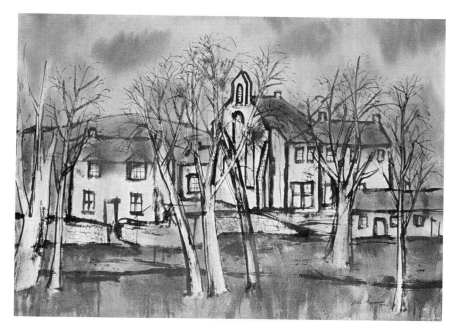

1. JOHN MAXWELL RSA *Winter Landscape, Dalbeattie 1948* 22½ × 30½
Collection George Neillands, Esq.

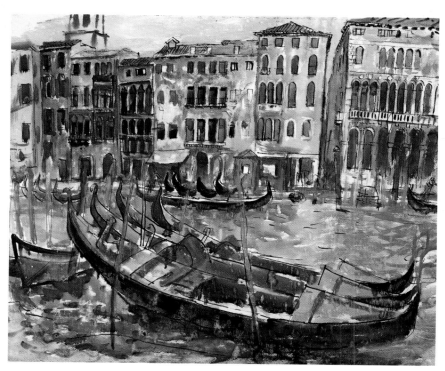

2. WILLIAM WILSON OBE RSA RSW *Venice* 22½ × 30½
Collection Scottish Arts Club

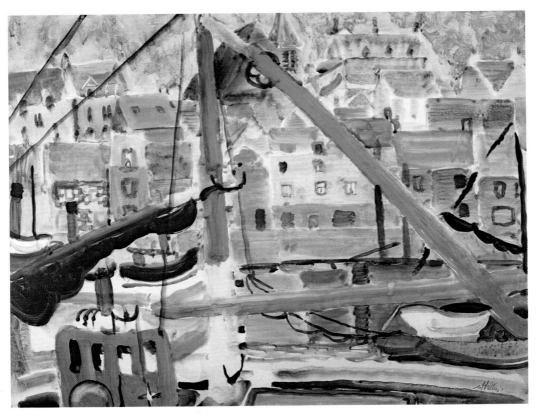

3. SIR WILLIAM GILLIES CBE RSA RA P/PRSW *St. Monance 1935* 20 × 25
Collection Sir Robin and Lady Philipson

2

FORERUNNERS

IN Scotland the nineteenth century produced, as in England, a great number of competent watercolour painters; there was much detail in execution and the standard watercolour of the late 1880s and 1890s was basically a drawing with carefully-applied colour, often heavily worked and sometimes framed in a deep, ornamental gold frame with or without a mount — sometimes they were gold too — and the total effect resembled an oil painting in its presentation. "Finish" was highly regarded by the exhibiting societies as well as the public and an artist who wished to achieve an element of spontaneity had to reckon with the established conventions of taste. Of course there were exceptions, as there always are, and artists of quality could from time to time paint beautiful watercolours — as could Sir David Wilkie, for example — although not professing specialism in the medium. There were also many competent portraits in watercolour, some of them small miracles of virtuosity. Portraiture has been regarded with caution by watercolour artists precisely because it presents such difficulties.

Spontaneity came into its own from the 1860s onwards in France when the Impressionists, mainly working in oil paint directly on the spot, found their attempts to capture the fleeting light effects of a given moment to be a handicap to Salon recognition. Their pictures looked just too sketchy and apparently unfinished. The mixed public exhibition has often imposed constraints on artists, simply because pictures are in competition with each other and it is too easy to rock the boat. Like the Pre-Raphaelites in England, the Impressionists were regarded as a disruptive element as far as their colour was concerned — it just didn't suit the rest of the exhibition wall. The Pre-Raphaelites did however, have an advantage over Monet and his associates in that their pictures most certainly did not lack "finish". Impressionist colour, relating directly to the retinal image of the motif and brought back "live", so to speak, from the outdoors and with the bright light of day in them, did not conform to the formula of the studio set-piece, painted entirely indoors. Impressionist pictures looked raw beside their fellows on the Salon walls alongside establishment work. Something had to go, and the establishment won, temporarily.

Thus in Scotland also, a painter like William McTaggart (1835-1910), essentially a direct artist who liked to work out of doors, only came to his "Impressionist" style (original, in his case) later in his career, when to paint in this manner had become slightly more acceptable, but even then it did not meet with universal acceptance. In the watercolour medium — secondary for him to his oil-painting — his work is delightfully fresh and spontaneous, despite the fact that, paradoxically, he often worked on his watercolours — begun out of doors — in his

studio during the evenings, after he had spent time with his family following the evening meal. McTaggart was a great family man and had a time and a place for everything.

He was one of the founder members of the Royal Scottish Society of Painters in Water-Colours in 1878, alongside that expert technician and sensitive painter of genre subjects Hugh Cameron. Pollock Sinclair Nisbet and Joseph Henderson were also early members and between 1880 and 1890 the Society's ranks were strengthened by several artists from among the Glasgow Boys — James Paterson (who also became its President), Arthur Melville, William York MacGregor, Thomas Millie Dow, Edward Arthur Walton (another RSW President), Joseph Crawhall and George Henry. MacGregor and Walton were fine painters in whatever medium they used and their watercolours are always sparklingly fresh. Henry produced some superb watercolours throughout his career, notably in some of his Japanese subjects and especially in the beautiful *Girl in a Cabbage Garden* in the Broughton House collection. Crawhall, a member for only six years (he resigned in 1893) was of course a draughtsman of magical dexterity and breathtaking economy of means. There are excellent examples of his exactly-remembered cameos of animals, birds and hunting scenes in the National Gallery of Scotland and more especially in Glasgow Art Gallery and Museum at Kelvingrove. His use of watercolour is always bound up with his mastery of line, movement and intuitive emphasis, all of which set him apart from most other artists in the animal field since Pisanello. Melville too was in a class of his own and will be dealt with in more detail later.

Other Glasgow School members of the RSW included Sir James Guthrie, distinguished in watercolour as in everything else he did, Grosvenor Thomas, James Whitelaw Hamilton and Robert Macaulay Stevenson. Among watercolour artists who were important in the closing years of the century were Sam Bough, who died in the Society's foundation year and who was outstanding as a draughtsman, a technician of great powers and a landscape artist capable of visionary depth; Edwin John Alexander with his exquisite animal and bird studies on silks or tinted papers, completely different from Crawhall's in their decorative refinement; Robert Gemmell Hutchison, a painter of great skill and sensitivity in genre themes; James Kay with his fresh and sometimes dazzling colour; the sparkling James Watterson Herald, under Melville's influence but in the end an original artist in his own right, and Tom Scott from the Borders, who was amazingly not a Society member (he was, however, a Royal Scottish Academician) but a painter who, despite inconsistencies of quality, could encapsulate his native countryside with a sure grasp of atmosphere and truth to locale.

There were others whose contribution to the heritage of Scottish watercolour has been noteworthy without being innovatory, and whose painting has a strong personal quality—Charles Mackie, Robert Alexander and Robert McGowan, Sir D. Y. Cameron — all too often remembered only for his superb etchings — and his sister Katharine Cameron, George Houston of the leafy Ayrshire landscapes,

3. PHILIP REEVES RSA RSW RE *Arran Shore*
Private Collection

4. ROBERT LEISHMAN **RSW** *He Makes Things Up, You Know* 25½ × 25
Collection the Artist

Charles Oppenheimer from the South West and, also from that Mecca of artists in Kirkcudbright, the talented and unusual Jessie Marion King with her sometimes off-beat colour and unmistakeable style with its undertones of Art Nouveau.

Real innovatory change came with Arthur Melville (1855-1904). Working almost a century ago, his watercolour technology was far ahead of its time and his contemporaries. Melville is one of those romantic figures in painting whose spirit of adventure carried over from his life-style into his work. An intrepid traveller, he journeyed in strange and sometimes perilous places to seek his subject interest, and like Gauguin in the Pacific, found his essential inspiration in new and exotic locations. For this he needed a different idiom and a new convention, together with the necessary form in which to present it. For one thing, he had to come to terms with dazzling heat and shimmering white light; with milling crowds thronging the market-places, ports and bull-rings; with the bright reds, blues, oranges and yellows of the Near East or Spain or North Africa in place of the permutations of green which saturate the British landscape. To do this he evolved a technique which looks as if it just happened on the paper but which in fact was full of the tricks of the trade. He made carefully-prepared and planned designs, taut and telling, painted only after he had arrived at the most economical abstraction of shape and colour. There was a lot of subtle tinting of large areas of paper, afterwards to be retained in the finished picture; big shapes were put in with a loaded brushful of paint in a stroke, and then left, so that their freshness remained. Crowds were distilled into droplets of colour, blobbed on to the paper with unerring skill in their placing in a way which miraculously suggests recession and density, while whole areas might be lightened in tone by dexterous sponging down to a ghostly image into which vital accents would later be slipped in exactly the right places. There have been other instances of this type of approach, notably Herald's in Scotland and, roughly contemporary with Melville in England, H. Brabazon-Brabazon, but without Melville's great sense of design and with considerably more random, expressionist bravura.

The genius of Charles Rennie Mackintosh (1868-1928) as an artist, belated in acknowledgement, has in the last ten years been recognised and thoroughly established in the public awareness through a remarkable and intensive campaign of research by scholars and admirers in Scotland, notably by the late Andrew McLaren Young, Professor of Fine Art at Glasgow University, and by Roger Bilcliffe, whose efforts have opened many eyes to Mackintosh's multiplicity of talents. But while his immense and internationally famous achievements in architectural design, in his unique interiors and in his incredible perfectionism in the creation of every part and detail destined to be used in those environments have been successively revealed, it is perhaps in the quality and standard of his draughtsmanship and his watercolour painting that the greatest surprise has been felt. Mackintosh emerges as a watercolour painter of major rank and one whose contribution to this field has given Scotland an artist of stature who was previously unthought-of in this connection outside of Glasgow. As might be expected, his style is one of planned design, with every square inch considered and with a meticulous drawing underlying everything.

But his colour is transparent, unworried and — if seldom really intense — always vibrant. There can have been few artists who could make a watercolour more truly monumental, whether in landscape or still-life with flowers. Not surprisingly, buildings feature strongly in his landscapes and they are observed by an eye which understands their structures and the relationship that must exist between a painted building and the space on which it stands. There is a lot of detail, invariably kept perfectly under control and never permitted to overpower the essential design. It is very doubtful whether Charles Rennie Mackintosh's watercolours have yet had time to exercise an influence on other artists or, for that matter, whether this is likely to happen. For one thing, draughtsmen of his ability are born once in a generation and few would have his ability to produce a picture with such consummate craftsmanship. In his hands a single vase of flowers on a dark table-top can take on a majestic quality and the flowers — although delineated with eagle-eyed precision — breathe a mysterious life of their own. Indeed it is this combination of mystery with accuracy which is so unusual and which gives Mackintosh the status of a master.

The outstanding Scottish painters of the 1920s and 1930s were undoubtedly the quartet usually referred to as "The Scottish Colourists" — a term coined by the late Tom Honeyman in his book about three of them, Peploe, Hunter and Cadell. But John Duncan Fergusson is usually nowadays included in the group for reasons of contemporaneity as well as style. One does not as a rule associate this group with watercolour in particular, but G. Leslie Hunter and Francis Campbell Boileau Cadell probably used the medium more than Fergusson or S. J. Peploe. Hunter's watercolours tend to be sketchy and summary in treatment but while they are often vivid in colour it is clear that he needed the sensuous medium of oil paint to realise the full potential of his sumptuous hues. Cadell is another matter and there is a sureness and panache about his stylish, apparently rapid impressions of the South of France or a city street which can remind the viewer of Marquet's economical simplicity.

This, then, is the background to the contemporary school of Scottish watercolour. To appreciate the achievement and impact of our present-day artists and to understand something of the difficulties they had to overcome, they should be seen in the context of this tradition. Before coming to examine their work in depth, there are one or two additional considerations of which we should take note.

One of the distinguishing characteristics of Scottish watercolour is its twentieth century look — it has been brought fully into this day and age. In these eighty years of change, art has changed as much as anything in science, in communication or transportation. Art from Giotto to Cézanne is a story of gradual development over six centuries. Changes — some of them startling, like Giotto's own work — took place, but the main objective was the representation of the visible world. Until the end of the nineteenth century the eye ruled the intellect, generally speaking. Since our own century began art has never stopped changing direction. First, colour was divorced from the visual appearances so closely studied by the Impressionists and became liberated through the painting of Gauguin and eventually the Fauves.

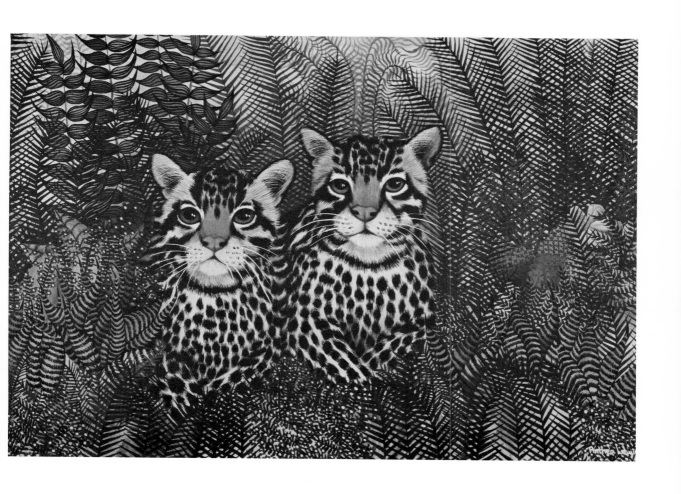

5. ANTHEA LEWIS RSW *Two Ocelots 1979* 8¼ × 11½
Collection the Artist

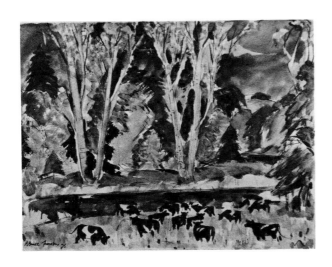

6. ADAM BRUCE THOMSON OBE RSA P/PRSW *Cattle, Tweedside 1975* 12 × 16
Collection Jack Firth

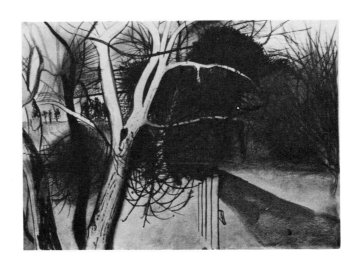

7. ROBERT HENDERSON BLYTH RSA RSW *The Copse, Winter*
10¾ × 14 Collection Jack Firth

Expressionism left artists free to treat the visible world roughly in order to demonstrate the power of their own emotional involvement. Primitive art and the painting of so-called "naive" artists, together with the art of children, were recognised as having a different aesthetic, while Cubism pushed the object behind the artist's own creation. Abstract art got rid of it altogether. Dadaism and Surrealism brought it back again, transformed and bewitched. The collage caused a revaluation of the materials of painting and meanwhile, wars, the spread of media communication, film and television all changed the artist's outlook and his imagery. Above all, the huge influence of information about the arts through reproductive printing processes and the growth of the art book and journal together with the mushrooming of popular magazines on a scale undreamed of even half a century ago, have all made André Malraux's *Musée Imaginaire* more and more of a reality.

All this poses problems for the young artist, faced with a bewilderment of knowledge. The work of artist-teachers is therefore of immense significance in guiding new talent through the labyrinth. In Scotland the vast majority of artists are also teachers and this is a key factor in the general development of the arts. All too often the hackneyed dictum — "He who cannot, teaches" — is mouthed by people who should know better than to quote Shaw on the visual arts, especially when he was not specifically referring to them. In Scotland education in art occupies a very important place in the education of our children and we are fortunate in our teachers in both the schools and the schools of art. The majority of teachers of art are practising artists, many of them of distinction, some of them being among the most influential artists working here today. The four Scottish colleges of art form a potent force for the professional training of potential artists, and despite the valuable and necessary rivalries between them, combine to exercise enormous influence on the arts.

Scotland too is unique in the closely-knit structure of its exhibiting bodies and they have an effect on the artistic life of the country which does not happen elsewhere. The five main annual national exhibitions — The Royal Scottish Academy, The Royal Scottish Society of Painters in Water-Colours, The Royal Glasgow Institute of the Fine Arts, The Society of Scottish Artists and the Scottish Society of Women Artists — all afford opportunities for artists to develop their work in professional company, and all exhibit watercolours. Never before have artists had greater opportunities to show their work than at the present time in Scotland, with these bodies forming the core of a huge range of galleries all over the country and even outside of the large urban centres. The membership of the RSW is largely drawn from the other societies and they, in their turn, provide watercolour artists with exhibiting possibilities.

The criterion for this account of Scottish watercolour is to be found on the walls of the Society's annual exhibition, where the medium is exhibited in a concentration not found elsewhere. I believe the range and importance of the work which appears on these walls to be exceptional in terms of twentieth century watercolour. It is time to examine the contribution made by the artists who have created this powerful contemporary school of painting.

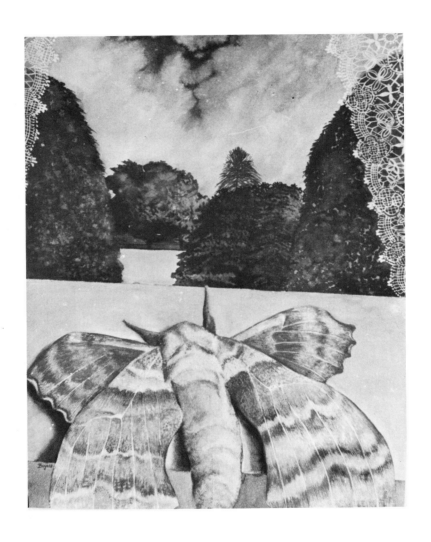

8. DONALD BUYERS RSW *The Moth 1977*
 Collection the Artist

3

Fluid Magic

LIKE all great colourists, John Maxwell (1905-62) understood better than most painters how to extract the maximum effect from minimal means. There is a painting called *Winter Landscape, Dalbeattie* which illustrates the point admirably. He would seem to have immersed the sheet of watercolour paper in water until it was saturated and then, with only French Ultramarine and Burnt Sienna for colours, laid down a veil of browns, pinks, purples, slate-blues and greys by mixing on the wet surface, controlling the flooding action of the paint so that a compositional structure emerged, while at the same time allowing certain passages to remain pure white. Finally, when the gradual drying process had reached the exact moment, he wove in a calligraphy of pen lines in Indian Ink — lines that could range from black velvet accents softened and fattened by the damp paper, to delicate, spidery wisps of line that reveal a beautifully sensitive observational drawing. Here and there the ink has mixed with the two colours to create additional colours — the rich purple-browns and neutralised blues. The effect is one of great richness which utterly belies the simplicity and economy of the means. This is the magic of watercolour in the hands of a master.

The wet watercolour combined with a counterpoint of pen line is not by any means a Scottish invention — nor is it even recent — but it is doubtful whether many painters have done it better, or with a finer regard for the balance of looseness and firmness than the Scottish watercolourists of the years between 1936 and 1960. John Maxwell was probably the virtuoso of the group of artists who brought this most flexible of methods into the context of twentieth century painting, and when he used the pen in his watercolours in the 'thirties some annoyance was felt by the purists who saw it as an affront to their narrow conception of watercolour. With Maxwell one always feels that colour and tone come first, the drawing being applied afterwards as a control and improvised on the original data of visual information available in the subject. The technique is both conscious and spontaneous, the "accidentals" which occur being nevertheless part of the artist's *gestalt*. The effect is at the same time immensely rich and economical.

We see of course only the finished performance. The preparatory crises and failures, legendary sacrifices in Maxwell's case, were rightly destroyed by an artist whose perfectionism could overcome his pleasure in creation and his pictures survived only if they could withstand his deadly self-criticism. Maxwell pictures are therefore rare and precious. Even when his output — never really prolific due to a complexity of circumstances which included, latterly, problems of health — was slowed down towards the end of his life, the cast-iron judgement remained so that only the best found their way into the frames. Those found wanting were ruthlessly destroyed.

He was not touched by actual fame in national terms although he had a market consisting of devoted collectors. There were many admirers who waited and hoped to be able to secure one of his paintings but there were never enough paintings to go round. As far as I am aware he did nothing consciously to augment his production of pictures in order to satisfy the demand. There is an authenticated case of a municipal gallery director who made a pilgrimage to the artist's studio to acquire a painting only to return empty-handed. He was told that the next one off the easel was already spoken for. By present-day standards the Maxwell public was a limited one. No real national acclaim was his, although he is modestly represented in the Tate Gallery. An Arts Council exhibition in 1954, which commenced in London and then toured, did not set the Thames on fire. The show was a joint one with William Gillies, a happy partnership personally but an imbalance in painting styles. No agents promoted him, comparatively little was written about him and in his time — not so very long ago. The kind of media intelligence which keeps us all so well informed today — the Sunday supplements, the television screen and the sponsored exhibition programme all geared together were non-existent. There has also been a dearth of art-writers and daily newspaper space for the arts in Scotland. Perhaps Johnny Maxwell would have thought all this merciful. His fame, like his work, was selective and although deeply cherished by his admirers, fairly localised. He hated fuss and was genuinely modest. It is a familiar pattern where Scottish painting is concerned. All too often the citadels of power are stormed posthumously.

John Maxwell's other world — the world of his pictures — was one that was intended to be enjoyed, but while it contained constant references to the things that we love — flowers, trees, birds and nature generally — only here and there can we actually identify with it because it was the world of his mind and his fantasy, a creation of his own, born out of his visual awareness, his perception and above all, his contemplation. What he painted is a distillation of his sensitive thought processes, duly meditated upon; he did not "paint nature" in terms of straight observational painting but paraphrased it to create a new and personal world. Redon and Chagall, two names frequently invoked when Maxwell is discussed, created a similar private world in their work. There is an affinity with Redon. Both he and Maxwell could make a vase of flowers vibrate with a glowing inner life which goes far beyond mere botanical still-life. Redon too, albeit with nineteenth century imagery, could make a new world through his colour, but there is a gloomy streak sometimes which is not in Maxwell's work. I have never seen much correspondence between Maxwell and Chagall, apart from the occasional juxtaposing of figures and flowers which occurs in both artists' work. The legendary Russian is much more extrovert, much more spectacular, and beside Maxwell his colour is almost strident. Paul Klee's vision is closer to Maxwell's; thoughtful, quietly rich, subtle and mysterious. Maxwell's world however, unlike Klee's, is more dependent upon the visual world. He builds his fantasy on what is basically observed truth — a truth that we can all see and recognise although not quite the same world that our own eyes see when we look about us. His landscapes were transformed even when they were about a place that he knew intimately, like Dalbeattie. There is improvisation on the theme. Maxwell was always fascinated by improvisation whether in painting or

9. JOHN MILLER RSA P/PRSW *Ben More from Iona* 15⅛ × 19¼
 Edinburgh City Art Centre Collection

music, and he had considerable gifts in music also (like Klee), being capable of playing piano improvisations at length — but for himself, not as a performer. So when he painted trees, they too are improvisations on tree forms. Trees like his can only be created out of a knowledge of trees and a feeling for their rightness of shape and structure. It is the same in the race of people who sometimes inhabit his landscapes as part of his mythical fauna. The distortions work because the anatomy of the figures is an extension of physiological truth.

The colour of Maxwell's paintings is selective and usually seems to conform to a chromatic theme which was decided for the picture before its commencement. Like many painters of great colouristic gifts he often worked in a restricted range of colour but with a dominant hue to which everything else was related. Instead of juggling with the spectrum he preferred to extract the greatest possible variety from a limited palette, producing beautiful subtleties along the way.

In the context of the watercolour painting of his own time and particularly in his earlier days, John Maxwell's pictures gave off strong vibrations which could be extremely disturbing to the tame delineations of the given scene which formed the bulk of the watercolours in public exhibitions. As a result he was not, in his younger days, a popular competeitor with the safe establishment — there was the pen line, and he used body-colour sometimes! And there were these figures! Knowing this, he was wary of having his work exposed to the whims and vagaries of selection juries. It would be nice to be able to find his name among the membership of Scotland's watercolour society, but it was not to be. Maxwell felt that he could not make it at that time, and on reflection he was probably right. He would have had quiet satisfaction could he have known that at the present time his reputation and fame have far outstripped and outlasted that of most of the people whose judgement he distrusted.

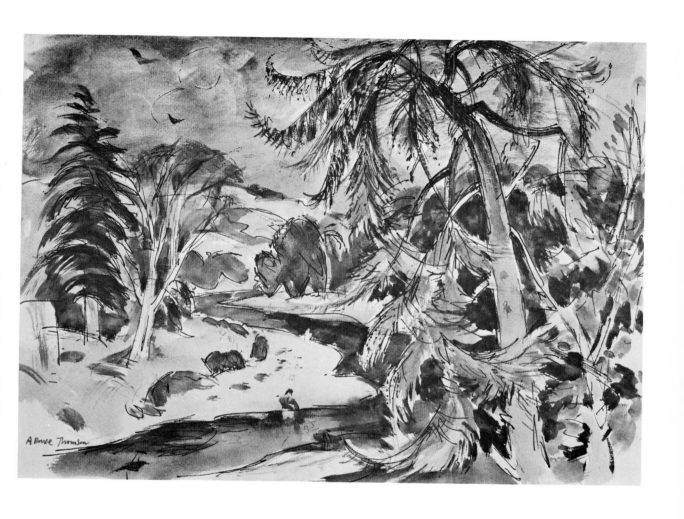

10. ADAM BRUCE THOMSON OBE RSA P/PRSW *The River Tweed above Melrose* 12⅝ × 16¾
 Edinburgh City Art Collection

4

The Emergence of a School

IT would be foolish to attempt to identify a single, special reason for the rise of Scottish watercolour as a potent force in the painting of the present time. Certainly, the work of pioneers is important in isolating the goals and setting the example, and from time to time such individuals are thrown together in working groups of one sort or another, giving rise to a collective drive. The example of the Glasgow Boys is a case in point. All individualists, they succeeded in generating a group dynamism of formidable power. Scottish watercolour has similarly benefitted from the common aims of individual artists who, although unaware of their role in communal terms, nevertheless combined to achieve a group impact. It is interesting to examine one example of such a movement.

Sir William Gillies (1898-1973) and John Maxwell could not have been more different as artists, but their names were inevitably linked in their young and not-so-young days simply because they were seen to be different from so many of their contemporaries, and also because both were products of Edinburgh College of Art. The East versus West attitude of mind has produced many misconceptions in Scottish art. But while the direct influence of Maxwell — through his work — on younger artists and students was probably fairly limited, Gillies exerted a profound and persistent influence on the way many other artists painted and saw their subjects.

A vintage watercolour by Gillies exhibits an easy command of the medium which is very difficult to describe in words. To understand its articulateness and fluency it becomes necessary to look at it. Gillies has been more important in the Scottish artistic scene from the 1930s to the 1970s than most people realise — even today, and for a great many reasons, only one of which is specifically concerned with his painting. Probably his greatest gift as a teacher was his own dedication and example, and never has an artist been more dedicated and married to his art. Painting was his life, despite a strong social sense which gave him many friendships, mostly enduring ones. But anything, from a necessary social occasion to years spent in administering first a painting school and then a whole College, which prevented him from painting was a matter for his regret. It is therefore small wonder that his painting has fluency — for him it was an everyday activity like talking or eating. Teaching was an everyday activity too and he loved being surrounded by people learning to paint and watching their art grow.

In his earlier years he was associated in painting with Donald Moodie, another artist of fluency and flair. Moodie was a really gifted draughtsman of apparently effortless and — to his students — shattering skill and he readily adopted the same kind of pen-and-colour watercolour style that Gillies and Maxwell used, often with

4. ROBERT HENDERSON BLYTH RSA RSW *Three Red Cottages* 12½ × 20
Collection Aberdeen Art Gallery

5. JAMES CUMMING RSA RSW *The Observatory* 22½ × 30½
Private Collection

6. PHILIP REEVES RSA RSW RE *Out of the Wood* 30 × 40
Collection the Artist

7. SIR ROBIN PHILIPSON PRSA ARA HRA RSW *That Other Winter* 25 × 30
Private Collection

dashing results and Moodie's contribution to the more flowing, spontaneous quality of Scottish watercolour should not be forgotten.

Gillies' own painting style in oils and watercolour was unmistakeably his own — particularly with regard to colour — and one which was forged out of many influences in his lifetime, assimilated and metamorphosed into his own style. He was always aware of what was happening in painting and was good at extracting what was of use to him. If this tends to suggest that Gillies was in any way exceptional in the range or number of his influences it is perhaps worth making the point that painters have always looked at the work of other artists with professional eyes. It is inevitable and normal and the absorbing of influences is the very stuff of art tradition and history.

In the 'twenties and 'thirties Gillies learned quite a lot from — on his own admission — Derain, perhaps more from Derain's post-cubist phase than his Fauve pictures, but in much of what Gillies did he had something of the Fauves too, particularly in his most liquid, intensely-hued watercolours just before and just after the second World War. Some of Gillies' most unusual oils reflect traces of Bonnard's daring with colour and if his ability to create new and strikingly unusual schemes of colour owes anything to outside influences it must be to the imaginative flair of Bonnard. Later on there are signs of Braque in Gillies' more structured and orderly still-life pictures, because he had that dichotomy in his make-up which allowed him to be both classical and expressionistic. His style, properly, was governed by the medium, and when he was handling watercolour he used it as naturally as it has ever been used.

Watercolour for Gillies was never formalised. The spontaneous properties of the medium took over and the paintings of the 1930s and 1940s, vital, very powerful in colour, totally liquid and intuitively inspired, show a strength of handling which few artists achieve in watercolour. Drawing, of course, underlies this apparent abandon of riotous colour and satisfying shorthand, and he was a great draughtsman. But lest all this implies that Gillies was merely a Fauve thirty years after the event, I do not believe that any member of that group would have painted the *St Monance* of 1935 the way he did. Furthermore, this painting would look neither out of place nor inferior, in a roomful of Derains, Dufys or Matisses.

The Indian Ink pen line played a big part in Gillies' watercolour technique at one time, although later he was to use a pencil line as part of his painting. He was one of the group of painters — Maxwell, Donald Moodie, Penelope Beaton, Adam Bruce Thomson and others — who used full-bodied watercolour with the line acting as a kind of lassoo, to tie a contrapuntal linear structure into the loose, wet banks of strong colour, anathema to the plodding journeymen of the day. It was, by some quaint process of logic, not quite cricket.

Some of Gillies' compositions, in their day, were daring and even startling. *Gardenstown* of 1950 is a case in point. Arthur Melville in *An Eastern Harbour* and *A Mediterranean Port,* both in Glasgow Art Gallery, used a device which was also

11. DAVID MARTIN RSW *Fylingdale Landscape* 22½ × 30½
Collection the Artist

startling — the sea was at the bottom of the picture and the land mass above. In *Gardenstown* Gillies did the reverse, with no sky at the top — the blue sea runs off the upper edge of the painting. Of course, like so many of his surprises, this one had a perfectly natural explanation in fact. This is the way Gardenstown looks from the top of its cliff, from which vantage point one feels that one could toss a stone down any of the chimneys of the terraced cottages below, but at the time it was arresting, because no one else had done it that way, and it is only on thinking about it later that it seems natural to have done this. Hindsight, as someone remarked, is always 20-20.

The Gillies way of looking at landscape is full of natural truths. His factuality is like Monet's at Giverny. When one is there it seems there is no other way the place could be painted. Gillies was mostly rooted in his own native locality — East Lothian and Midlothian, and although he tried France and moved about Scotland constantly in search of subjects, taking in the Borders, Banffshire, the North East Highlands and the Stewartry, it was back home that he could always find the gentle russets, fawns and greyed yellows, pungent greens, cerulean and the violet blues with which he identified and on which he could play endless variations — again, like Maxwell, he was an improvisor. The result of Gillies' focussing on his locality has been a tendency for landscape artists — especially in the East of Scotland — to experience difficulty in seeing the scene other than through his vision. If he taught a generation how to look, he also caused some to form the habit of reproducing some of his surface effects. The best among those others eventually overcame the strength of this influence to arrive at the "personal" style which Gillies would have wished them to find for themselves, but there is still a lot of him in our painting today. "Personal", was his favourite adjective of praise.

The "Edinburgh School" then owes some of its vision and quite a lot of its loose, fluent handling of pigment to William Gillies. It is also bound up with Gillies' own influences as well as with those of other important foundation members. In watercolour as in oils, the style is generally soft rather than hard-edged — "painterly", to use the expression of the trade. This term is too vague to be either satisfactory or accurate and many a hard-edge painter would dispute it. But in the meaning of the term as it is generally and loosely understood, there is no more "painterly" artist in Scotland today than David Donaldson, Head of Painting in Glasgow School of Art and Queen's Limner for Scotland. Donaldson, however, has a boldness and essentially tangible quality in his subjects — an earthier quality — which is quite unlike the Edinburgh manner. The influences are different, I believe, as is the actual milieu of West of Scotland painting. Glasgow has one of the greatest collections of 19th Century French painting outside of France itself, and I have sometimes thought that Glasgow artists are more interested in that middle period in 19th Century French art before the excessive lightening of the palette took place through Impressionism. Certainly, Glasgow painters' feet don't leave the ground in the same way as has sometimes happened in the East of Scotland. To remain with Donaldson (although he is not primarily a watercolourist) when he creates his powerful imaginative compositions based on Biblical themes the figures have a weight which causes them to exist in fact and not simply as wraiths of paint, however elegant and seductive the brushwork. It all contrasts markedly with the work of the

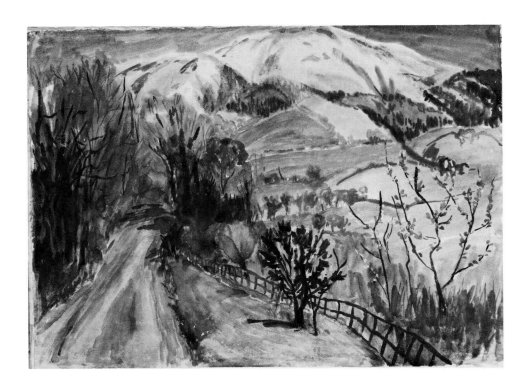

12. PENELOPE BEATON ARSA RSW *Road near Applethwaite* 19½ × 26½
Edinburgh City Art Centre Collection

East of Scotland's great manipulator of paint, Sir Robin Philipson, and this curious difference of approach and of style in two cities only forty-six miles apart gives to Scottish painting a diversity which is both fortunate and valuable for the vigour of our national "school". Nevertheless, the actual causes of these marked differences between artists of West and East Scotland constitute an intriguing puzzle. Perhaps the respective appraoches to the matter of drawing have a bearing on it all. At the risk of falling victim to what must be a sweeping generalisation, I would hazard the notion that while both schools regard drawing as a fundamental, basic tool, the emphasis in Glasgow School drawing has tended to be towards concrete reality of form, boldly stated after analytical observation, positive and sculptural; the Edinburgh approach is lighter in touch, a sensitive feeling-out and exploration of form, with perhaps rather more consciousness of the intrinsic qualities of the drawing itself. It is an interesting digression at any rate, and one which merits closer study.

Anne Redpath (1895-1965) was an enormous influence on Edinburgh-based painting, although she was not a teacher. Essentially loose in her use of paint, adept with the most sensuous properties of the pigment, capable of finding sumptuous

colour values in greys, off-whites and soft colours opposed to others of strength, she had something of that quality of deliciousness — a combination of intuition and judgement, directness and experience in knowing just what to do with colour, texture, strength and delicacy — possessed by a painter like Christopher Wood, echoes of which quality one can see in Maxwell also. She had a genuinely French feeling in her work, perhaps born out of a lengthy sojourn there, and this is seen in her sense of decoration in paint, in the beautiful and untroubled surfaces and in the importance of what, for want of a better word I would call the sheer "taste" of the painting. Her watercolours usually have a bold and summary structure of linear drawing — never complete enough in itself to stand without the colour for which it was the foundation. Her richness of colour and the sense of adventure which always seemed to guide her in its use made her painting memorable in any company.

To return to William Gillies — towards the end of his life he painted the *Still Life with Colour Box* of 1967, a watercolour almost Chinese in its spare, concise handling but with vibrant tensions of colour. It was inspired by nothing more important than what lay on the painting table in front of him and demonstrated his ability to regard the commonplace with wonder and then to re-present it for us to share in the discovery. When Gillies was working, totally absorbed and filled with enjoyment as the drawing grew on the paper and the line, the colour, the placing and the accents flowed intuitively from his immense experience, sensitivity and knowledge, he could be a superb communicator of pleasure. The only message was the painting.

There is another factor of importance in trying to identify the elusive character and the formative events which have shaped the "Edinburgh School" and this goes beyond purely aesthetic considerations. Gillies had a huge capacity for inspiring loyalty in his colleagues and associates, and it is probably this as much as anything which caused the rise of the "School". Second to his family and then, after finding himself the sole survivor of that, first in his thoughts, the College of Art, its staff and its students became his other family. His loyalty to his College matched that of its members to him. This factor has been neglected in assessing the "Edinburgh School" of painting. Many of Gillies' protégés have become in their turn influential, mainly through their teaching activities not only in Edinburgh itself but also in Dundee and Aberdeen and even in Glasgow. So the Edinburgh influence has spread geographically and as so many of its products have been watercolour painters of distinction, the effect of the "School" has been widespread, although it would be easy to over-emphasise this. But when one thinks of the impact on Scottish painting of William Wilson and Robert Henderson Blyth in their day, and of Elizabeth Blackadder, David McClure, John Houston, Alexander Campbell and a host of other outstanding watercolour artists of more recent times, it will be seen that the Edinburgh influence on watercolour, although by no means the only one of significance, has been a potent contribution to the scene.

Insularity nevertheless can lead to parochialism and there have been moments when Edinburgh looked like falling victim to this. It has therefore been fortunate that from time to time other stylistic influences have been injected into its

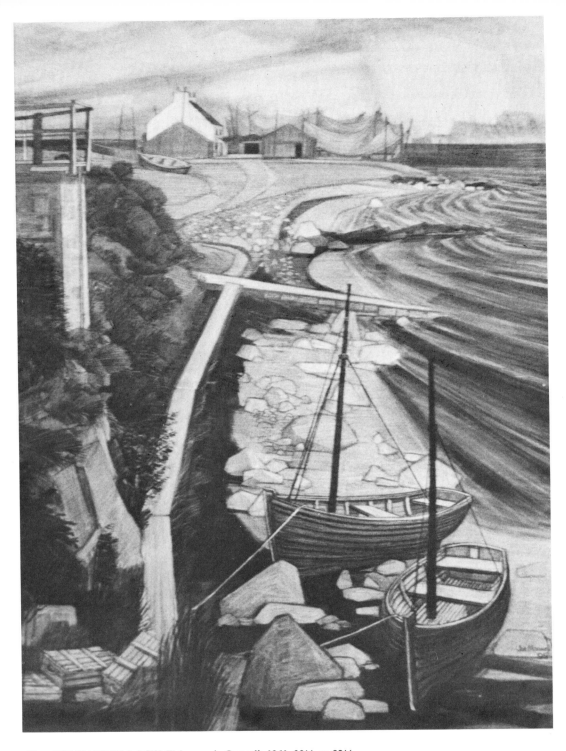

13. JOE MAXWELL RSW *Fishermen's Catwalk 1961* 30½ × 22½
Collection Jack Firth

bloodstream. In the decade after the Second World War, Leonard Rosoman joined the College Staff. He, with Henderson Blyth — although not in any conscious alliance — sparked off among students another new way of observing the commonplace. Rosoman's professionally innocent eye and his tight control of a design, combined with a deftness and sensitivity in painting technique, were infectious, as were his wry humour, fascination with textures and unusual sense of colour. He was also an artist who understood tonal values, as did Blyth. The look of student work began to change slightly. Rosoman was involved in two notable events about this time — the Living Traditions of Scotland exhibition in the Royal Scottish Museum during the Festival of 1951, and the great Diaghilev Festival exhibition in the College of Art in 1954. In the former he was commissioned to paint large mural backgrounds on the theme of Scotland's fishing communities, while he was in charge of decoration for the latter. Both events not only made his work widely known to other Scottish artists but also played an important role in the experience of the team of senior students who assisted him.

The emergence, too, of what has come to be known as "The 57 Gallery Group" (founded in that year) in Edinburgh was of great importance in shaping our present-day painting. The original painters of this lively gallery instituted something of a "palace revolution" in the Edinburgh climate of loose handling, soft-edged colour and the approach through *belle-matière,* and as the 57 Gallery was democratically operated by the young artists who exhibited in it, with Arts Council and other financial help, it was enabled to keep its motives pure. They caused more than just a stir. First of all, their tiny premises — 57 George Street, then a miniscule shop in Rose Street — could not contain them when they felt really ambitious and at Festivals they promoted their exhibitions elsewhere, mounting several large exhibitions in the new University buildings in George Square, where their clearly distinctive house style made a considerable impact. They also brought several memorable loan exhibitions to Edinburgh, by artists with whose work they were in sympathy. Their own style was something new in Edinburgh — or in Scotland, for that matter. Here were young artists who looked away from the domestic scene for their inspiration, away from the mainstream idols of a previous generation to a new set of household gods — Léger, Otto Dix, Georg Grosz and Max Beckmann, to Pop Art (then new), to Hockney and Patrick Procktor and Peter Blake. Their dead-pan realism, spare and stark, unseductive and even sometimes brutal (much of the German art they were studying had every reason to be brutal), could make the gallery-goer stop in his tracks, his mouth and his catalogue open in surprise. In the midst of all the seductiveness of what the late Sydney Goodsir Smith (then Art Critic on *The Scotsman*) called *l'école d'Edimbourg,* such influences were salutary and greatly strengthened the painting climate in the Capital.

The 57 Group is mentioned here in the context of stylistic change in the "Edinburgh School" during the 1960s and many of its artists will be referred to at greater length later in the story, but it would be an ommission to pass over the names of some of those who raised the new flag and kept it flying during the Gallery's formative years. The Gallery was founded in 1957 by Daphne Dyce Sharp, herself a student in the School of Sculpture at Edinburgh, when she offered the premises she

had acquired as a studio for exhibition purposes to other young artists. An association was set up under the initial chairmanship of Patrick Nuttgens, an architect, but thereafter the impetus depended very largely on the coincidence of the emergence of John Bellany and Alexander Moffat as powerful young talents of an expressionist outlook, together with the solid hard work of mature artists like Bob Callender (chairman of the Gallery and twice President of the Society of Scottish Artists) and John Busby. The poet Alan Bold had a significant role also as literary communicator for the Social Realists in the Group, and functioned in this capacity as a latter-day Apollinaire, with great effect.

Meanwhile William Gillies himself lost nothing as a result of all this and was in fact the most enthusiastic encourager of new talent and new ideas, recruiting many of the newcomers to his painting staff in the College. Under his personal influence watercolour painting thrived and flourished, never more so than during his Presidency of the RSW when he extended the changes of attitude within the Society which had, slightly earlier, been brought about by the liberalism of John Gray and Adam Bruce Thomson during their terms in office.

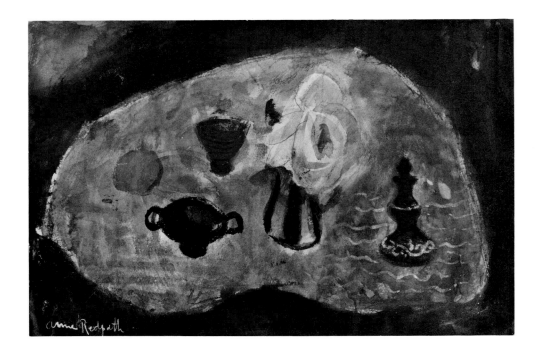

14. ANNE REDPATH OBE RSA ARA *A Single Rose* 14¾ × 22
Private Collection

5

A Gentle Boldness

THIS disertation on Scottish watercolour is not intended to be a historical survey in strictly chronological terms. It is mainly concerned with finding some of the artists and movements which would seem to have been instrumental in shaping its characteristics. It is therefore fitting that we should consider some of the painters who have brought about changes in attitude, working methods and vision, and in this connection it may also be appropriate to consider the part played by one or two of them whose importance lies in their effect as catalysts.

Watercolour painting has for a century been, in Scotland, bound up with the disposition and climate of the Royal Scottish Society of Painters in Water-Colours. At times the Society was competent but dull, fairly static and occasionally stultifying, a condition not infrequently encountered in established societies of artists. It has been observed on many occasions that members of such societies have begun life as non-conformists — anti-establishment and fiercely critical of their seniors. This is the way of life. But times change as do people, and when security eventually arrives and the former dissidents are admitted into the charmed circle, history has a nasty habit of repeating itself and self-preservation takes over from idealism. It was Goethe who said that the first task of all revolutionaries is to prevent any future revolutions. Happily, however, the forces of real talent are also engaged in the struggle, and generally, if often belatedly, talent will out. Painting and painters eventually change; artists are primarily individualists and non-conformists, and in due course enough of these tip the scales in the other direction.

Under the Presidency of John Gray during the years prior to 1957, The Royal Scottish Society of Painters in Water-Colours underwent certain changes of attitude — slight but significant — which paved the way for more far-reaching events to come. Gray was a subtle and sensitive painter of restraint and modesty rather than an innovator, and as an artist of patent honesty himself he could recognise and encourage younger talent when he saw it. It was this attitude at the top of the Society which enabled the rising generation of watercolour painters to be seen and felt. His liberal approach as a President and his striving for freshness and excellence in all that the Society did marked a big step forward. While still professionally very selective in admitting new members, the Society's doors were opened wider than before and new names and styles came into its membership. The pattern of its walls gradually altered and a new vigour appeared.

Adam Bruce Thomson (1884-1976) who succeeded John Gray, maintained and extended this attitude with his customary professional integrity and also with an eye for potential talent. He, like John Gray, could not be considered an innovator in watercolour but he brought to everything he painted a fresh, direct, robust and

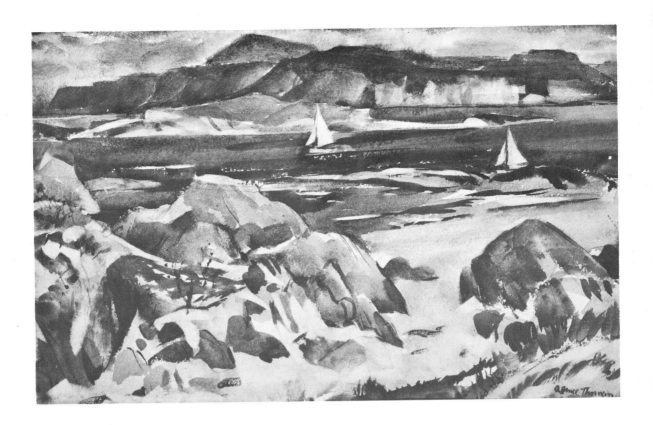

15. ADAM BRUCE THOMSON OBE RSA P/PRSW *The Sound of Iona 14 × 16*
Private Collection

vigorous emphasis of design and colour which could only enrich the walls of an exhibition. Throughout his long and productive life he never stopped striving for improvement, for change where necessary and, above all, for total honesty of outlook. It is hard to think of any other painter who was more himself and less subject to outside influences. Influences, had he discovered them in his own work, would have been in all probability considered slightly false in the first instance, and then only put to use after the most careful consideration. His style is always lively, bold, always knowledgeably colour-orchestrated and invariably his own attempt to communicate his artistic vision.

Painting with a profound appreciation of all aspects of art, he forged a style which conveys his own character to an extraordinary degree. Never a much-travelled artist, he derived his stimulus from the landscape terrain of Scotland and if there is any particularly "Scottish" use of colour which one can recognise (as has been claimed in some quarters) then Bruce Thomson must come to mind — his colour seems to be so much a part of the Scottish landscape that it is difficult to imagine

how it might have been applied elsewhere. His favourite locations were Iona, Plockton and the eastern Border country, with Edinburgh and its environs as a perennial source of ideas. A long life-time of teaching at the College of Art there made his name and work familiar to students and artists over some sixty years and when, in late age, he attained his Presidency of the RSW, his own bold example set the tone for the Society. When at ninety he painted the consummate view of Edinburgh — *Allotments and Arthur's Seat* — it all came together. In the Border country, especially around Melrose (where in season he could also take in the Seven-a-Sides) he was at his most relaxed. It was then that he could effortlessly organise the strong rich blues, purples, deep greens and sonorous amber browns which he saw there and which gave him so much obvious delight. A lot of his own painting vitality transferred itself to the Society. *Cattle, Tweedside* was painted when he was ninety-one with the same direct gaze that never left him, for he retained his sharp eyesight even at that age. As a teacher he of course taught all aspects of painting and drawing, but he is remembered by many for the etching classes in the College which were for so long held under his exacting but benevolent instruction. One artist who is always associated with those classes was William Wilson (1905-1972).

The Wilson style of watercolour is akin to that of Adam Bruce Thomson but with some marked differences. Both used the pen and watercolour technique of Gillies, Maxwell and the others — Bruce Thomson perhaps less frequently — but Willie Wilson's compositional arrangements seem less consciously designed and more of seizing upon a natural arrangement with an artist's eye. They are amazingly direct. Also, he was pre-eminently a stained-glass artist and his use of colour is distinctively rich and with a lower tonality, sometimes verging on the sombre but always opulent. He did not paint in oils and for his watercolours chose his subject matter from the fishing villages of Fife and the East Coast and, notably, in Paris among the colour-washed, shuttered façades of the old streets on the Right Bank up as far as Montmartre. Venetian subjects also fascinated him and he dealt with them with a superb economy of drawing and a beautifully closely-knit sense of design, perfectly in tune with the compacted streets and canals. Wilson was a superlative draughtsman all his active life, a fact which his early etchings admirably demonstrate, but it is hard to tell whether the drawing or the painting came first in his watercolours. The draughtsmanship is careful yet rapid, with great professional organisation and disarming freedom. The slashing pen strokes which delineate architecture or boats or gondolas hit the paper with the accuracy of darts thrown by an expert. When Willie Wilson lost his eyesight in mid-career it was a loss for everyone, but he continued to work in the interest of art and artists in the Academy and College for his remaining years, to the benefit of everyone concerned.

In the 'fifties and 'sixties new and now-familiar names appeared on the watercolour scene to complement the work of those painters of consistently high quality and originality whose pictures stood out from the rest. For years, artists such as William Geissler with his often audacious explosions of colour and William Burns who stayed with his North East harbours from the early representational pictures to his later abstracted symbolism injected strength into the walls of watercolour

exhibitions. Robert Scott Irvine brought a cool, analytical order through carefully formalised design in landscape and an impeccable painting technique. His paintings can induce a mood of grave stillness, the result of carefully planned design in a more English fashion than is normally found in painting north of the Border — there is something of the Nash brothers and of Bawden or Ravilious but the style and the colour are unmistakeably Scott Irvine's own. From the West, John Miller's great tonal discretion and subtlety, William Armour's modestly-scaled distillations of hills and lochs and changing weather, and the robust and positive approach of his wife Mary Armour with her rich, fearless colour in both landscape and still-life all brought their distinctive quality to exhibitions. Sinclair Thomson's sonorous, brooding landscapes too, introduced a more powerful use of watercolour than was commonly seen, carrying all the impact of oil painting, but with the elusiveness which is always present in watercolour. John Miller (1911-1975) succeeded Gillies as President of the RSW in 1967, seemed to epitomise the West of Scotland water--colour character in his forceful drawing and deep colour values within a lower tonal scheme than is normally employed by artists in the East. His paintings of the Clyde coast where he lived sum up the atmosphere and the moods and the dark grandeur which can be seen there, especially in winter. Miller also painted glowing flower-pieces and is as well known for them as for his landscapes.

Penelope Beaton (1886-1963) known like others mentioned here, to countless students through her activities as a teacher at Edinburgh College of Art, had in common with several of her distaff contemporaries, to struggle for recognition in a male-dominated art climate in days before female artistic emancipation arrived. She finally and somewhat belatedly achieved some measure of success by reason of her almost masculine dash and verve, her spontaneity and willingness to take a chance with the medium. Her best watercolours are spirited and flowing. It would be interesting to speculate whether the struggle for feminine emancipation in painting produced the strength which is so much a characteristic of some of our best women artists. Today, artists can be equally of either sex without causing any surprise. In the years before the Second War, and more especially before the First War, there were artists and women artists. Women who have made an impact in recent Scottish painting have mostly been powerful painters — one thinks of course of Joan Eardley as well as Penelope Beaton, Mary Armour and Anne Redpath, and of an earlier generation there were Bessie Macnicol and Lily M. McDougall, not to mention Jessie M. King, although her boldness lies in her originality rather than in her painting technique.

One essentially feminine artist of a different kind was the late Brenda Mark; the description does not imply any lack of strength but rather a subtlety and delicacy of colour and presentation allied to strong drawing which to some extent continued something of Maxwell's imagery of girls and flowers and occasionally a sharply-seen landscape, with a haunting atmosphere and soft, clear colours. She died tragically young and at the height of her artistic powers, but her contribution to Scottish painting of her time was a noteworthy one.

The new liberalism of the RSW was by the 'sixties causing rapid changes on its

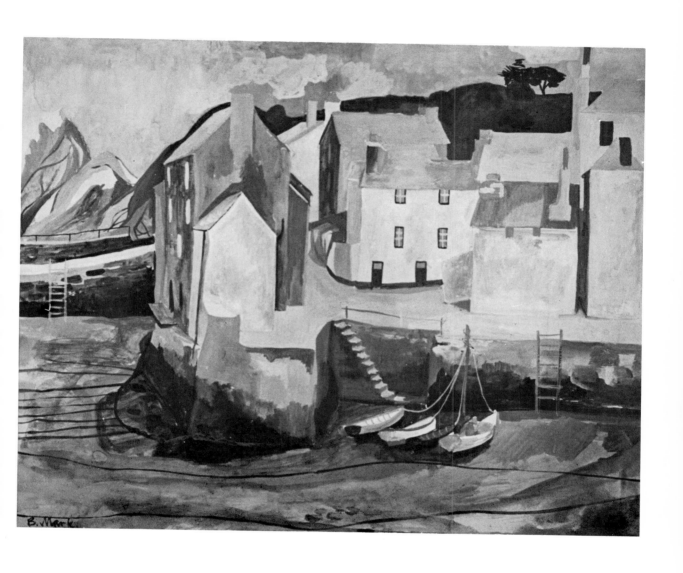

16. BRENDA MARK RSW *Polperro* 11 × 15
Collection Mrs Hilary McCallum

walls as a procession of now-familiar names passed into its membership. Some of these will be the subject of special comment later on, but a glance at their names will point to the significance of this period in the Society's history. Robin Philipson, Robert Henderson Blyth, John Houston, Philip Reeves, James Cumming, David Martin, William Baillie, Elizabeth Blackadder, James Robertson, Joseph Maxwell, Barbara Balmer, David McClure, Alberto Morrocco, George Mackie and John B. Fleming all made their appearance as watercolourists, although of course some were already well-known as painters in oils. The Society was growing in strength and authority at an astonishing rate.

Painters either from the East Coast of Scotland or domiciled there might be expected to make use of the great wealth of material which lies along its seaboard. Ian Fleming, although born in the West, was already a distinguished painter and an influential teacher who for many years has enlivened the watercolour exhibitions with his sharply-observed subjects set in the fishing villages of Fife, Angus, Banffshire and Aberdeenshire, often with that idiosyncrasy of vision which sets his work apart from the mere topography of a place. His painting in watercolour is perhaps drier than that practised by many of his contemporaries, and it is taut in design, crisp in handling and sure in draughtmanship.

William Burns (1921-1972) began in similar vein, painting over the North East coastal material of harbour villages and the houses of the fishing communities in a brooding style with colour that tended to be sombre. He eventually came to abstract, simplify and finally to symbolise and invent out of the shapes of pier and harbour, boat and buoy, creating a personal visual language. In watercolour as in his oils, the colour is predominantly red — the colour of red lead on the hull of a boat — and his pictures became colour fields in which floated the abstracted shapes of the objects which for him encapsulated the whole world of man and the sea. Abstract art of any sort is comparatively rare in Scottish painting, but when it does occur and the subject matter becomes of secondary importance to the making of the painting, the artist generally leaves a representational clue for the viewer, to guide him to his meaning. Burns' abstracted maritime shapes are very much the essence of the thing seen. His early death while flying his aircraft robbed Scottish painting of a most interesting talent. In view of their present-day reputation as colourists, it is interesting to recall that both David McClure and John Houston also made use of this maritime subject matter, exploiting the possibilities of a grey dominance in much of their work at that time. Robert Henderson Blyth produced his first mature work in similar surroundings and no doubt artists will continue to exploit the rich vein of material in East Coast villages into the future, although paddling pools in

some of the harbours and plastic speed-boats in garish colours do tend to obscure the interesting shapes of the old cottages and textured alley-ways. John B. Fleming's paintings of the sea — although not his exclusive subject matter — are of a different kind and evoke the full swell of the ocean and deep water. He has for many years painted and taught in the West, living in Dumbarton and teaching at Glasgow School of Art, and much of his material in watercolour is drawn from Naval associations with the sea, in which he can achieve a very distinct mood and, without

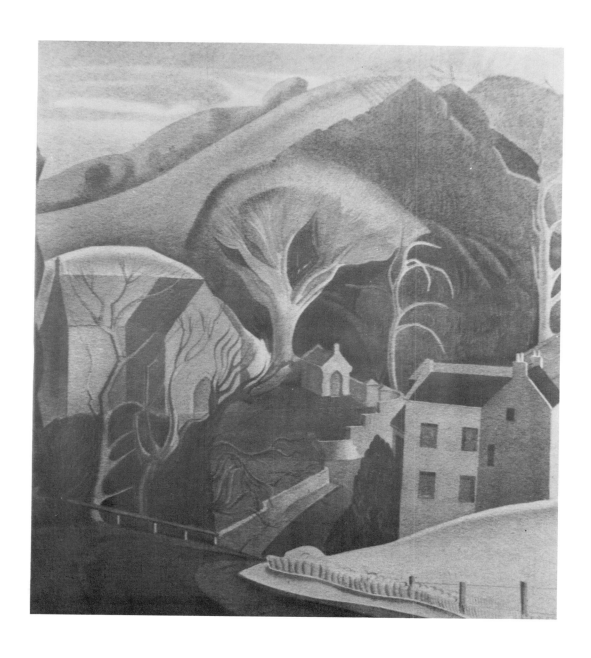

17. ROBERT SCOTT IRVINE RSW *Church and Manse, Temple* 17½ × 16
Lothian Region Schools Picture Collection

being what is usually referred to as a "marine painter", he emphasises the structure of sky and waves through compact design and unusual colour. He has recently ranged beyond this theme and has softened his approach with a more mysterious, ambivalent atmosphere in his landscapes.

Another painter of the East Coast who has been a distinctive presence in watercolour exhibitions for many years is Leonard Gray. An artist with a very recognisable style and "colour-signature" all his own, he has painted fishing village subjects frequently but by no means exclusively, being attracted also to other landscape themes which give him scope for his painting manner and unified picture surface. A painted texture often extends over the whole picture, weaving in and out of the shapes of buildings or paths, over the sky and causing all the elements of the picture to be brought together through colour — rather like the dappling caused by sunlight. His work is always place-conscious and full of the essential character of the locale, whether it be the East Neuk or a farm-steading or a hillside in Tuscany.

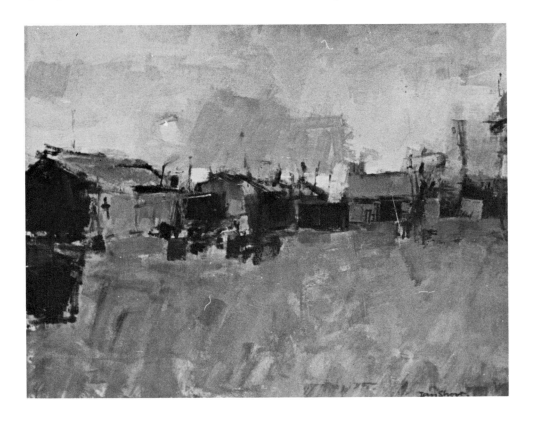

18. IAN SHORT RSW *Harbour Outhouses, Footdee* 26 × 30
Collection the Artist

19. DAVID EVANS ARSA RSW ARCA *The Room near the Hills* 20 × 38
Collection the Artist

The late Alexander Allan, also from the East Coast, contributed some of the most original and unusual essays in colour during the 1960s. There was no mistaking the personal quality of his chromatic inventions, and his daring but controlled juxtapositioning of disparate hues sang a song quite unlike anyone else's. His subject-matter could be equally inventive. Landscape played a large part, whether localised or on an Italian theme, but is was in his use of his own posessions and surroundings in still-life paintings and interiors that he was at his surprising best. Although he never strayed too far from natural appearances, his manner of seeing things—direct and sophisticated drawing and, above all, the unfolding of unexpected patterns of colour and shape—was unique. To paint pictures in watercolour based on a bathroom shelf, or out of a collection of bric-a-brac such as candlesticks, packets, soap dishes or radishes would be a test of creativity for any painter; to make them also memorable and absorbingly interesting and decorative is a very rare accomplishment. Latterly, a cat found its way into his still-lifes, and with

that kind of visual self-effacement associated with comouflage, lent its own markings and patterning to the compositional scheme.

Two artists with whom watercolour is not normally associated but who have brought to it the same qualities that they display in oils are Frances Walker, now from Aberdeen, and William Crosbie, an elder statesman from the West of Scotland. Frances Walker is a painter of authoritative draughtsmanship who stays with the observed scene and invests it with her characteristic boldness and verve. There is a positiveness in all her work—a searching analysis of the forms before her and a linear emphasis in her drawings and occasional watercolours which produces surface unity but also tensions of shape. William Crosbie is a remarkable and wholly individual artist of great distinction who over many years has demonstrated his mastery of his craft, his command of picture-making and a profound understanding of all the ways in which artists have expressed themselves, past and present. He approaches each painting as a new and exploratory experience, never content to repeat a success but boldly evolving a style or an idiom to clothe his pictorial idea. In much of his work he has been ahead of his time and although he is not normally associated with watercolour as a medium, it is typical of him that his approach in this is sensitively in tune with the fluid nature of the technique.

Joseph Maxwell's cool and characteristic green improvisations on the theme of leafy lanes, archways and tunnels of trees with sharp distant glimpses of rolling hills and fields caught up between them have been part of the watercolour scene too for about twenty years, with a tightly controlled design and a static, formal quality which can create a world of monumental calm and stillness. His subject matter has ranged widely from time to time and in oils his themes are very different, being concerned with domestic interiors and portraits as often as landscapes, but it is in the latter that he is most at one with his theme and where his ability to organise his picture gets most scope.

The strong design and characteristic orange-red dominance of David Martin's paintings have been familiar focal points in watercolour exhibitions since the 'sixties, and he is an artist who seldom stays still in his work for very long, changing and developing but without losing his natural style of picture-making. Basically a landscape painter, he has nevertheless seldom been content in recent years with objective truth, and the landscape when it emerges is in his own mould, Romantic in feeling and emphatic in its presence.

Alberto Morrocco is not primarily a watercolour painter but, as one of Scotland's most distinguished artists, when he paints in this medium he brings to it the same qualities of professionalism and flair that mark his oils — together with the warmth of his beloved Italy, because very many of his subjects are Italian landscapes or scenes of beaches and bathers painted in rich colour. He has no limits to his subject matter and paints all manner of themes, often with figures, for he is a most accomplished draughtsman. There are other painters of long-standing who might be referred to at this juncture when we are dealing with those whose watercolours appeared during the fruitful 1960s, but I shall discuss them in a later section because of the interesting developments taking place in their recent work.

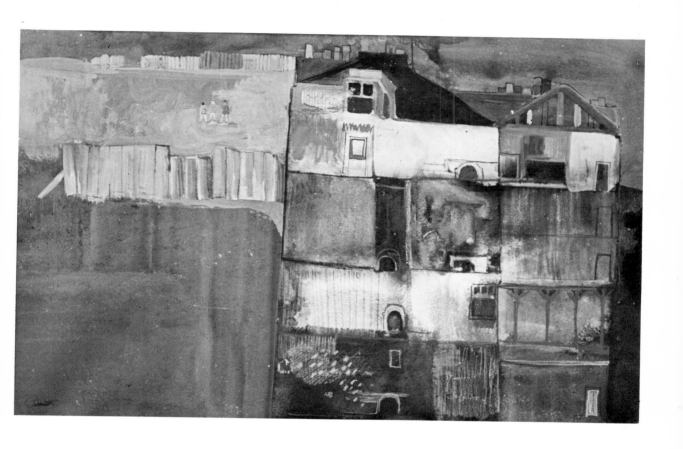

20. GEORGE JOHNSTON RSW *Space to Play* 22½ × 30½
Private Collection

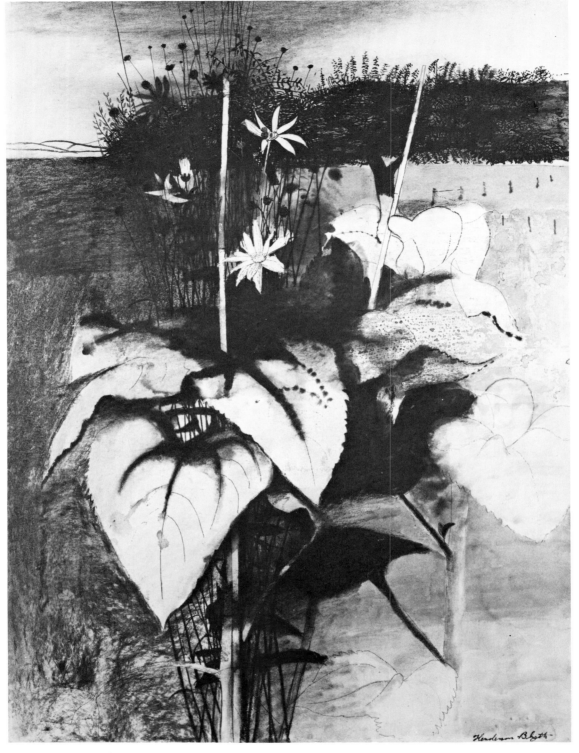

21. ROBERT HENDERSON BLYTH RSA RSW *Leaves of a Sunflower 1961* 27 × 19¾
Collection Aberdeen Art Gallery

6

The Antidote of Tone

ROBERT HENDERSON BLYTH (1919-1970) trained at Glasgow School of Art before the Second World War, had a year at Hospitalfield House summer school at Arbroath under James Cowie, served as an orderly in the R.A.M.C. and did enough war drawings to attract notice and to be represented in the collection of the Imperial War Museum. After finishing his service he joined the staff of Edinburgh College of Art and then some years later taught at Gray's School of Art, Aberdeen, becoming Head of the Painting School there in 1960. He had therefore an unrivalled experience of institutions of artistic learning and this varied experience was reflected in his interesting and distinctive style. He used to say that because he had been in so many centres of art, none of them actually owned him, but in fact he was aware that in his work he represented an amalgam of attitudes, styles and outlooks, which is one reason he is such an interesting artist.

Out of the sure drawing and bold emphasis which was his Glasgow heritage, he initially evolved an extremely personal and almost monochromatic approach to painting, startling in its use of blacks — he is one of the comparatively small number of artists who can use black as a colour—sometimes with livid whites and with small, sharp notes of intense colour, often a pungent green. In oils this had a rivetting effect; in watercolour it was so unusual as to be immediately recognisable from the far side of a large gallery. Watercolour is supposed to be a luminous medium and generally, this is taken to mean eschewing the use of areas of black or dark brown. Black would seem to be the negation of luminosity. Blyth could make it positively glow. He was essentially a disciplined artist, and this he learned, I am sure, from James Cowie. Before examining Blyth's work in depth it seems necessary to consider Cowie himself.

Writing of F. Spencer Gore, Walter Sickert said "An artist is he who can take a flint and wring from it attar of roses". He might have been speaking of James Cowie. Cowie (1886-1956) was born in Aberdeenshire, started to study for a degree in English literature, changed course for art and became a teacher. When he had saved enough to pay for a course of art training he went for two years to Glasgow School of Art and studied under Maurice Grieffenhagen. He emerged to teach art at Bellshill Academy and remained there for over twenty years, and it was there that most of his best work was done. Other artist-teachers who attain Academic status have normally done most of their teaching in schools of art, so Cowie is unusual in this, as in everything else he did as a painter. He had, however, to wait for his recognition. His style was intellectual and introspective; dry, linear in the most searching and uncompromising fashion, accurate and sure; his subjects were the bric-a-brac of his studio (or the Art Room at Bellshill) — plaster casts, figurines, pieces of glass and mirror, apples, books, arranged as slightly metaphysical still-

lifes, often against a window-view. He painted large and ambitious figure arrangements of students or school pupils, composed like Poussin but dressed unbecomingly in fairly drab attire — even, sometimes, gym-tunics. They were all

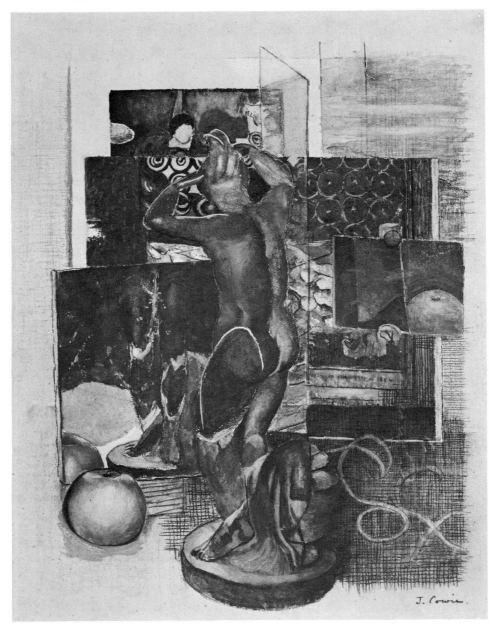

22. JAMES COWIE RSA *An Apple and its Reflection* 15⅞ × 11⅞
Collection Aberdeen Art Gallery

observed with that kind of intense gaze one associates with Stanley Spencer, although Cowie admired Paul Nash more. Portraits too, were equally uncompromising. His colour, like his painting touch, was unfelicitous and unseductive, the paint quality thin, to match. Yet this highly individual artist had a power and an oddly haunting quality which is not easily forgotten or dismissed. In the context of his own time these unpopular characteristics were in line with Cowie's implacable refusal to court favour by doing anything cosily seductive. In his watercolours he produced some masterly works, different from anyone else's. Robert Henderson Blyth, therefore, had a valuable experience at Hospitalfield, and his own painting seemed always to contain — in addition to this discipline — Cowie's ability to create a distinct mood, a feeling of the unusual. Cowie was also essentially a picture-maker, and Blyth remained at all times a compositional organiser. Sometimes he would undergo a phase when he seemed to be seeing everything from near ground level, so that the minutiae of the fields or the hedgerows loom large with almost surrealist implications, while the horizon appears just below the picture's upper edge. The monochrome *Leaves of a Sunflower* in Aberdeen Art Gallery, is typical. There was also a predilection for dense areas of vegetation within which could be discerned a remarkable amount of suggested detail, but outside of which would be an edge along which the detail would be minutely observed.

After his move to Aberdeenshire, a new interest in colour became apparent. The tonal, textural preoccupation with surfaces and the seizing of unusual viewpoints gave way to an enjoyment of strong colour and a much more lush painting surface, but the artist's eye for a subject never disappeared, although for a time, until he came to terms with this change of emphasis, some of his organisation gave place to looser handling of paint.

In 1950 he had accompanied Gillies on a painting expedition to the North East, to the Banffshire coast in particular, and their enthusiasm for the pictorial possibilities in the fishing villages of Gardenstown and Pennan, as well as for the immediate hinterland of the county, is evident in the paintings that each produced. Blyth, to be sure, learned a lot from Gillies, who could have a persuasive effect on the way other people worked, and something of him was discernable in Henderson Blyth's paintings at this time, especially when they both happened to paint the same subject. But if there was a Gillies influence it was quickly absorbed and adapted by an artist whose originality was never in doubt. Had he lived, the outcome of his later interest in colour allied to his powerful tonal control and sense of design could only have been memorable.

As it was, the painting of at least two colleges benefitted from Blyth's absorbing preoccupation with tonal values and shape-awareness, as did Scottish watercolour painting. He had a great deal to do with the new strength which watercolour could be shown to possess, and for the value of the sparing use of powerful colour in small significant areas offset by larger passages of more neutral greys, browns or black. But these are technical matters. What establishes Henderson Blyth as a key-figure in the post-war resurgence of watercolour in Scotland is not only his professional skills but his very personal, sometimes idiosyncratic, witty and original vision.

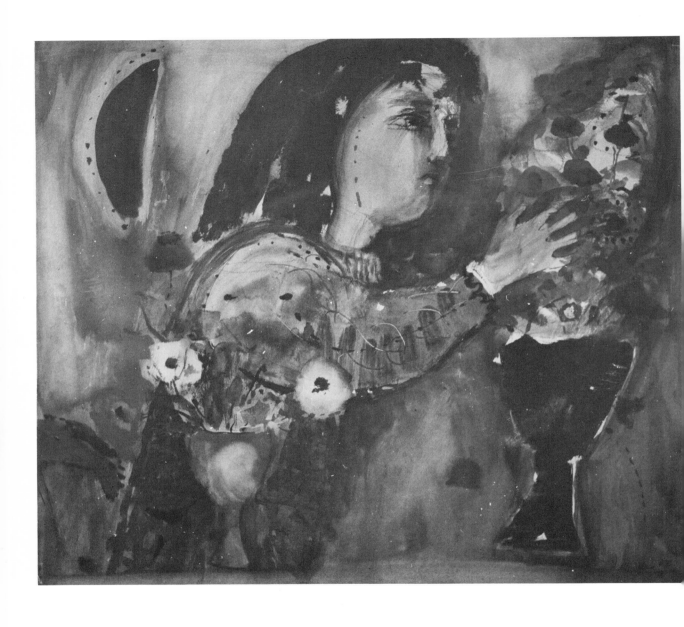

23. DAVID McCLURE RSA RSW *Figure and Flowers 1964*
Private Collection

7

Attack by Scale

TRADITIONALLY, watercolour has always been considered a medium which is naturally associated with pictures of modest size. Its historical role as a sketching technique has much to do with this attitude. Even when, in the past, it has been explored as a vehicle for expression in its own right, the scale has tended to be small and many of the greatest masterpieces in watercolour have been of miniature size. The scale of its equipment, too, had a bearing on this — small cakes of colour in a box or tubes which never approach the size of those for oil paint; the size of the brushes and, above all, the sheer practical difficulty of keeping large expanses of paper wet and fresh. Paper sizes in themselves tended to make for a limitation in scale, although larger sheets have long been available. Between the wars, watercolour exhibitions presented a monotony of size and shape — Imperial size was the maximum and the majority of the remainder were half that, and there was little variation even in proportion, the paper sizes being largely accepted. There was also the feeling that masters like Turner could create gems no bigger than the page of a pocket sketch-book. Even in his later days in the first half of the nineteenth century he seldom ventured on to a large piece of paper for his most uninhibited work.

It may be useful to mention also the curious, self-inflicted restrictions which artists have imposed on themselves by setting up unwritten rules for the management of pictures in watercolour. There was for many years a school of thought that considered it not quite cricket to employ body-colour, or more especially, white pigment. The paper had to be preserved in the "highlights" in all its virgin whiteness, a belief which has given rise to some of the more meaningless travesties of tone ever to hang on exhibition walls. Even more curiously, this notion is still with us, here and there. This is a strange belief in view of the countless precedents for the use of watercolour. Most of the masters of the past employed it at some time. Then the use of a pen line with ink was, as has been noted already, considered in some way to be "impure", while any suggestion of opaque body-colour with a trace of impasto could easily have excluded the picture from watercolour exhibitions. The question — "But is it watercolour?" has often been asked by selection committees and there have been debates about the legitmacy of other water-based media, such as acrylic and polymer paints used as watercolour.

From all of this it will be seen that in order to arrive at its present-day liberated condition, Scottish watercolour has had to come a long way. To return to the matter of scale, the contemporary scene in England has boasted of only one artist working in watercolour on a really large scale. Edward Burra was outstanding in his ability to handle large areas without losing any freshness — despite his use of transparent pigment in the main — and on occasion he has butted two large sheets of paper together. It is therefore all the more significant that during the watercolour

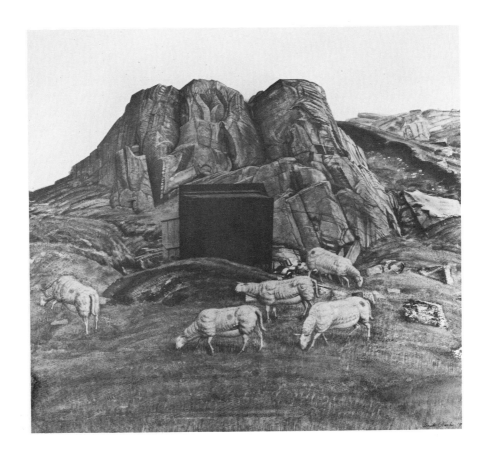

24. DEREK CLARKE RSW RP *Triple Rock and Sheep 1972* 23 × 24
Collection Mrs Mary Taubman

renaissance in Scotland during the last thirty years, the appearance of large-scale pictures is no longer unusual. That this phenomenon is largely due to Sir Robin Philipson few would doubt. Philipson is a painter who has for many years carried out outsized works in the oil medium and who has demonstrated a facility in the manipulation of fluent paint which is second to none. His really big watercolours date from around 1960, when he painted *The Burning* (Scottish National Gallery of Modern Art) a triptych in which all three panels combine to a total width of eight feet and a height of four and a half feet. The subject was no ordinary one, and this seems to me to be an important factor in the creation of very large works, which all artists do not understand. The picture is a monumental visual poem on the subject of the sacrifice of life, couched in the imagery of martyrdom but without explicit iconography. The feeling of the actual burning at the stake — a universal symbol for ritual death and the needless wasting of human life — and the subsequent charred deathliness are achieved through an expressionistic use of colour and the emotional handling of paint. This theme therefore, deeply felt, must have seemed to require no ordinary format. Philipson is an artist who habitually works in series, reiterating

58

and expanding a theme, and the burning motif, although his only major essay in watercolour devoted to this subject, was the prototype of such a series in oils. What seems to be of importance in the context of watercolour is that he has subsequently carried out other big watercolours in which his virtuosity has had full rein, and has shown the capacity of the medium for statements of a profound nature. Other artists have followed suit in the matter of scale, but so far their moving into a larger format has been for pictorial reasons rather than because of the significance of their themes in human terms of life and death. It must be said however, that few artists are so motivated, whether in oils or watercolour.

Robin Philipson is of course an artist with an explosive energy in all that he does, one who uses watercolour with controlled abandon, often mixing the media in mysterious ways — watercolour and acrylic, watercolour and oil paint, powder pigment mixed into liquid paint, collage-like techniques involving filmy pieces of Japanese paper embedded in layers of oil paint, and other variations. In watercolour, the wet and extremely rich colour fields which he can maintain right across the surface of the paper are, as well as being marvels of virtuosity in handling, very much in the soft-edged Edinburgh idiom, with all the seduction that this can produce, and this manner has had its effect on other painting. When Philipson first started to attract notice many years ago, there were two outstanding characteristics in his work — his tremendous confidence in paint and a painting style which seemed outside the mainstream of Scottish art, nearer to central Europe than to the Auld Alliance influence from France. Over the years he has, unquestionably, given to the watercolour a stature and a potential of power which have greatly contributed to its importance, not only because of the intrinsic value of his painting but also because, like other pioneer painters, his work points towards new goals. Some of his odalisques and those mysterious, shadowy groups of "waiting women", decked in a decorative eroticism, both disturbing and beautiful, spectacularly luxurious They are heady and feminine and if the air that surrounds them is scented it is the kind of perfume that advertisements assure us can drive men mad. Robin Philipson is a spectacular painter by any standards and because of this and because of his role as an educator, artistic eminence and President of the Royal Scottish Academy, his impact on our national school of watercolour has been very great indeed.

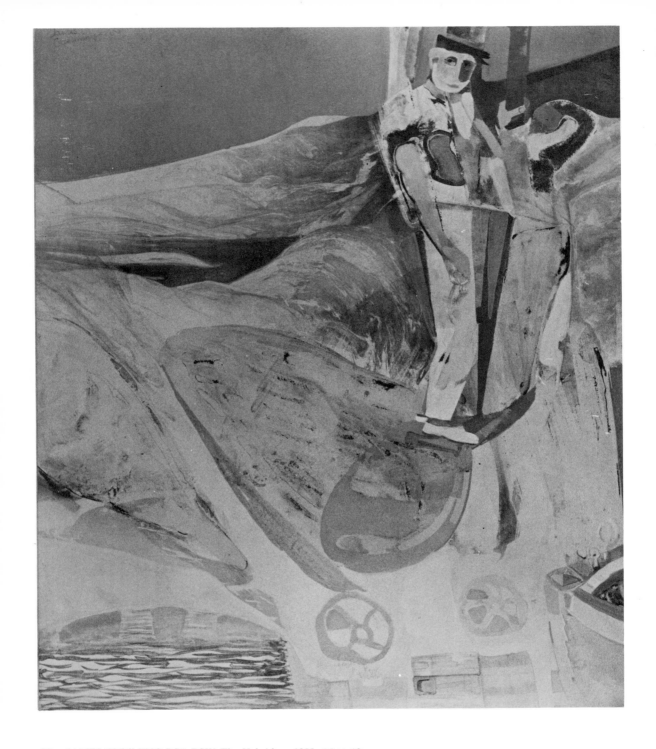

25. JAMES CUMMING RSA RSW *The Hebridean 1955* 16 × 12
Collection the Artist

8

Bending the Rules

WHEN one enters a gallery full of watercolours there are certain Scottish artists whose work proclaims their identity even before the exact nature of the picture can be discerned — it is like recognising a friend a long way off before he gets close enough for his face to be seen. Many artists produce this kind of work and one of the most distinctive is James Cumming. It would be a mistake to think of him specifically as a watercolour painter — a fact we must bear in mind all through this account when we are dealing with artists whose reputation does not depend on commitment to any one medium. Cumming would be distinctive no matter what his medium, but the fact remains that he does paint distinguished watercolours which, like all his work, are unique. One reason for this distinctiveness is that his paintings appear less representational than most in Scottish painting. The point has been made earlier that abstract art of any kind is uncommon in Scotland. But Cumming is, in fact, one of our most committed figurative painters and it is only in recent times that he has given the superficial impression of having moved away from figuration. There can be few other artists for whom the actual theme or subject of a painting has more significance.

When he commenced to exhibit he was profoundly figurative — but with a difference. In the late 1950s his titles spoke of *The Lewis Water Carrier, The Peg Legged Tinker, Brine Vessels, The Woman with Second Sight, The Oil Lamp in the Still-Room,* and similar unfamiliar iconography, derived from a period of living on the Island of Lewis following his Post Graduate training at Edinburgh college of Art. When other students about to embark on the great adventure of the Travelling Scholarship elected to study art in Florence, or Venice, or Rome, Paris or Spain, Cumming plumped for Lewis, in the Hebrides. He extended his stay there and became steeped in the lore of the islands to such an extent that this constituted his principal subject-matter over a long period which took him into maturity as a painter as well as to the stage of national recognition. Most people who have not lived in the Hebrides don't know too much about those parts and I suspect that for many, Cumming's place-names in his picture titles were the first time such names as Carloway and Callanish and Breasclet had been encountered. These paintings were not documentary (in the usual sense) and not at all topographical, but strangely-wrought, filled with telling images of people dressed in curious grey or brown attire, with emphatic distortions affecting the proportions of their limbs, especially the extremities of hands and feet. They were engaged in the chores of the place — fishermen, a loomsman, a poacher, a man carrying paraffin in a large drum, and so on. Usually their forms were integrated and merged with the landscape in a way that was happening elsewhere at that period of the romantic painting of the post-war years — Keith Vaughan comes to mind, but this is certainly not to imply any direct

influence on Cumming. Every part of the picture was made to contribute to the whole concept and, in an intangible fashion, there were echoes of Cubism — even of Futurism — here and there.

This type of figurative painting in which the personnages are integrated with the landscape is not, of course, a new approach. After all, there are precedents for most things in art. One thinks back to the late paintings of William McTaggart, when the ubiquitous children — for McTaggart was a Victorian artist and the "story" element was still expected — finally became one with his meadows and beaches; and then there was Hornel, who did the same thing with young people in woodland settings. But here any resemblance between James Cumming and other artists ends. He has always been the greatest individualist of his day, so far as Scotland is concerned, and his Hebridean imagery was entirely his own thing.

The interwoven shapes of the figures — usually one, at most, two — with their surroundings, while always within sight of the subject, assumed a separate significance as an abstract creation in their own right. Usually colour was kept strictly to a restricted palette, inclining towards the brown-red range. The problem was a formal one for him and form is best dealt with without the emotional complications of sensuous colour. Picasso and Braque knew this in their purest phase of Cubism.

Cumming depends not all upon the accidental felicities of the medium, whether oils, acrylics or polymers, or watercolour. He is of that family of painters, like Wyndham Lewis or Ben Nicholson or James Cowie, whose every mark follows the dictates of his intellect. So each area, and in Cumming's case, every sub-area, is consciously designed, arranged, weighed and subjected to his desire for emphasis or reticence as the case may be. This could make for tortuousness but he is never guilty of that. One of his many secrets is that, when he applies his brush, the touch is wonderfully light and his colour is put down with a total absence of fuss. In watercolour, this is a rare gift. When Cumming develops a small area of his paper he endeavours to impart the maximum interest to its commensurate with the overall schema, so every square inch is made vital. Although I would be certain that there is no stylistic derivation, Cumming's work can remind me of the paintings of the Glasgow-born John Quinton Pringle in this respect. Working in the 'twenties, Pringle had this involvement with the abstract detailing of the surface, as his *The Hen Run* in the Scottish National Gallery of Modern Art and the two small oils — *Muslin Street* and *The Loom* — in the Edinburgh City Art Collection demonstrate. His paintings however, like Cumming's, have a total absence of fussiness; they flow.

Cumming's technique in watercolour, as in his oils, is complex. Paint is made to work and never takes over, but such is his command that he can still do this and retain its true, fresh purity. He is a believer in using the best means to achieve his ends. Collage, for example, is sometimes part of his technical resources.

After about eighteen years with the Hebridean themes he felt he had to make a break. I remember him saying so during an extremely successful exhibition in Aitken Dott's Scottish Gallery in 1962, when the Lewis subjects were apparently at

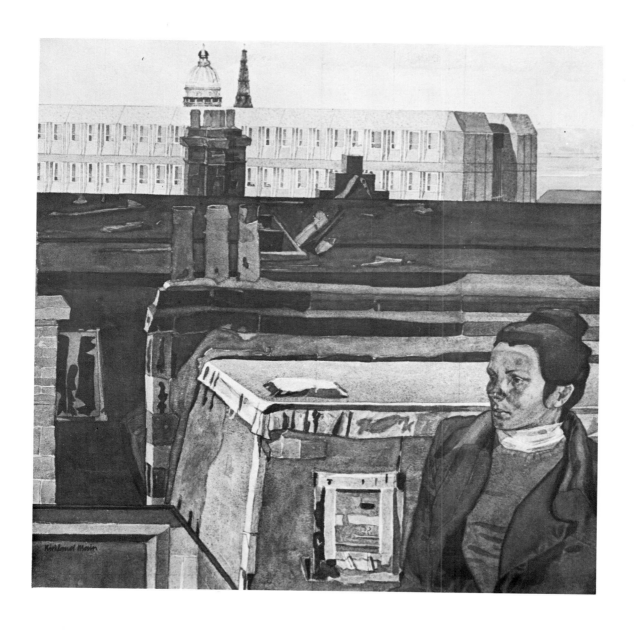

26. KIRKLAND MAIN ARSA RSW *Preliminary Monoliths* 20 × 20
 Collection the Artist

their peak and about six years before he actually made the change. When changes as complete and as unexpected as Cumming's occur in the work of an established artist, the effect is usually startling and disturbing to his admirers. Victor Pasmore, for example, went comparatively suddenly from his delicate, soft-focus type of Impressionism in Thames-side landscapes to complete non-representation, first in paintings of whorls and spirals, then to perspex reliefs, then to a kind of minimal painting in which purely formal tensions, movements and vibrations are caused to appear. With Cumming it was not a rapid change and he spent time contemplating the situation before the new paintings made their appearance. When they did, they took on the outward shapes and colours of the laboratory image — cellular clusters which suggested the photo-micrograph, the slide specimen, and sometimes the apparatus of scientific investigation. I recalled Kenneth Clark in his *Landscape into Art* in 1949, speaking of the anthropocentric notion of "nature" as being that part of the world not created by man and which we perceive with our senses. Lord Clark then went on to point out how the influence of the microscope on our conception of the

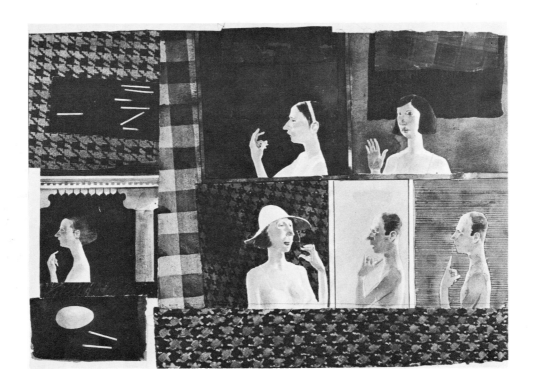

27. GEORGE DONALD ARSA RSW *Trying to Explain* 22 × 32½
Collection of Mr and Mrs R. R. Duff

64

8. ELIZABETH BLACKADDER RSA RA RSW *Still Life with Toys* 25 × 37
Private Collection, USA

9. JAMES ROBERTSON ARSA RSW *Red Landscape* 30 × 40
Collection the Artist

10. WILLIAM CROSBIE RSA *Odalisk 1946* 22 × 15
Collection the Artist

11. GORDON BRYCE ARSA RSW *Sheep Pen* 26 × 60
Collection the Artist

universe had immeasurably widened our whole idea of existence. He referred to the similarity to microscopic scrutiny of some of the paintings of Klee and Miro. Now we had, in James Cumming, an artist who had consciously set out to explore the microcosm which reveals the macrocosm. The titles which began to appear tell the story of the change. *Nerve Channel, Carbon Origin, Blue Fulcrum, Medulla — Pink Synthesis* and *Polaroid Screen* were certainly about scientific matters, but the really interesting thing is that they were also first and foremost paintings able to take their place as satisfying objects in themselves, and wrought with all the sensitivity and artistic perception that we had come to accept. In watercolour the flat field of colour and the straight clean edge are rare, and they might seem to be the negation of the medium. Cumming's watercolours overcome this hazard by their pictorial qualities, and his colour is now given free rein to emerge as among the most distinctive on our gallery walls today.

Watercolour therefore, has once more gained in scope from the work of an artist who appears to have broken some of the rules, and in this respect it has also moved even more completely into the twentieth century. There are other painters who similarly ignore traditional attitudes.

Philip Reeves is Scottish only by adoption, but has been for about twenty years teaching at Glasgow School of Art and exhibiting in Scotland. His training took place at Cheltenham and the Royal College of Art and he is unusual among leading painters in being a fellow of the Royal Society of Painters, Etchers and Engravers. It was as a printmaker that he originally made an impression but it is through his watercolours that he has become widely known. Printmaking is an ingenious medium, concerned with much forward planning and inventive calculation of effects. It is not therefore too surprising that a very distinguished printmaker's approach to watercolour should produce something different. Reeves is primarily, in his imagery, a landscape artist, in which category he fits into the Scottish art scene perfectly — Scotland must be one of the last places where landscape is still one of the major sources of subject-matter for painters. The word "abstract" is always slightly suspect in art, because it tends to have whatever meaning the user gives it, but if it is taken literally, to abstract from landscape — meaning to draw from — is an acceptable description of what Philip Reeves does in his paintings. His landscapes are not at all topographical; rather, they are contemplative, remembered images of remote coastal features in the north of Scotland, rock faces, escarpments and outcrops, gullys and chimneys in the rock, cliff-tops and sky, valleys and hillsides, all studied and observed first-hand by someone whose feeling for texture and shape is highly developed. He works through collage techniques using torn and cut papers, painted and stained and textured by his own hand — he does not use "found" materials nearly as much as most collagists and in consequence his papers and colours will retain their original appearance when ready-made colours of paper might change. Usually, there is a pronounced stratification of layers of inter-locking shapes which sensitively and evocatively convey the precise effect of the conformation of landmass that he is communicating. The craftsmanship is always superb, which is more than can be said for some artists who use collage in their pictures like a runner in a paper-chase. Edges are carefully observed, his complex

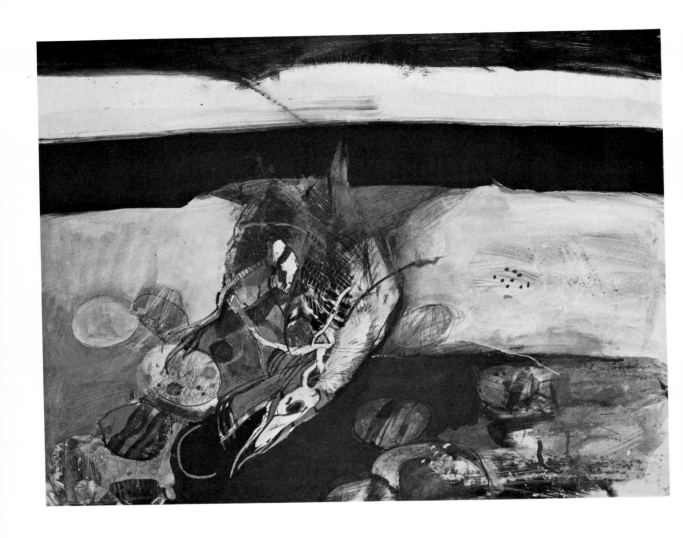

28. BARBARA RAE RSW *Seagull and Stones 1979* 20¾ × 25½
Private Collection

structure of paper fragments, slivers, shreddings and larger pieces is strong and secure. The result, despite the unusual material and the unorthodox use of watercolour or gouache with it remains essenially of the watercolour family, delicate yet strong, subtle yet powerful, beautifully designed and fresh in treatment. No doubt he could do this in oils but, I think wisely, he keeps within the technical range which his mastery of watercolour collage has made available to him. I have never heard anyone suggest that Reeves' paintings are not really watercolours. Perhaps this is due to his obvious affinity with the elusive, textural aspects of the medium; perhaps as a result of some of the other pioneers in Scottish watercolour as well as of Reeves himself, we are in a more enlightened and sensible climate than existed only a few years ago, when it is likely that Reeves' work would have been rejected by the watercolour purists. As a result of his imaginative and thoughtful contribution, our watercolour school is immeasurably richer.

George Donald's unorthodox and inventive approach to painting has also been carried over into watercolour and another unmistakeably individual style has enlivened watercolour exhibitions. He is a printmaker too, and in his painting on canvas had earlier introduced a certain three-dimensional quality with advancing or receding areas of the surface, sometimes by a kind of quilting technique using padding. His imagery is less dependent upon observation of natural appearances than most of the artists being discussed here, and is strongly-coloured, lively in pattern and often humorous and witty, using found textures and arbitrary materials in true collage spirit and in an entirely different fashion from Reeves.

Among younger and newer-comers too, Barbara Rae employs collage techniques in her powerful, geological-looking landscapes, and her watercolours carry just as big an impact as her oils. She is unusual in her preoccupation with black as the dominant pigment in almost every picture she makes — even the watercolours — and from what seems to be a most restricted colour range she can extract a surprisingly wide variety of effects, but always with black dominating. Black is of course capable of warmth or coldness, it can be brown-black or blue-black or red-black or purple-black or any of the other permutations and tonally it is, and has always been, the uncomplicated essence and stuff of tone. So perhaps its full range, when all its possibilities are exploited, is not as surprising as it would at first seem. It is also a neutral element alongside colours and so Barbara Rae's sparing use of vivid colour in small notes is given emphatic effect, and she is yet another Scottish artist whose works are adding to the ever-widening scope of watercolour.

If I have dwelt fairly frequently in the last few pages on matters of painting technique and the unorthodox use of materials in watercolour, perhaps I should correct any impression that unorthodoxy is in any way meritorious by itself. The justification for daring and adventure in the use of materials can only reside in the final quality of the result, and all the painters I have mentioned need no special praise from me. They all have had enough sheer painting ability to be able to command their materials, and without this foundation the off-beat use of mixed-media techniques would be mere gimmicry. Watercolour, however, has come a long way since its main tool was the ability to apply a flat wash.

67

29. JAMES MORRISON ARSA RSW *Classical Landscape* 48 × 36
Collection R. Booth, Esq.

9

Landscape and Beyond

MENTION has already been made of the incidence of landscape as a subject in Scottish painting — even today — and pictures either of landscapes or derived from an aspect of it would appear to constitute a particularly Scottish approach to painting. Much of this must be owing to our tradition and also to the concentration on landscape all through the nineteenth century, not only here but in France, the influences of which have always had a strong effect on Scottish art. Scotland is of course rich in painting grounds, and when the close study of landscape from nature was perhaps the main occupation of painters, there were favourite areas; Kirkcudbright always attracted Hornel, Japan notwithstanding, as it has continued to attract artists ever since. Cockburnspath in Berwickshire was the "in" place for Guthrie and Walton, then their allegiance shifted to Cambuskenneth. Even in more recent times certain places have been in the fashion, like Loch Lomondside for Leslie Hunter and Iona for Peploe and Cadell. How much of this was fortuitous and coincidental with places which were good holiday spots as well as offering painting possibilities is a matter for speculation. Joan Eardley came across Catterline in Kincardineshire by chance, but the sight of it was enough to win her devotion. It is likely that she had reached a point in her painting where it provided exactly the right vehicle for what she felt she wanted to do next.

Many painters of course, take the landscape they find — in their own backyard, and exploit its possibilities. In the context of painting today, it is what the artist does with the place that is important — his picture is his own creation, obeying his laws and conforming to his order of things. The landscape itself may be a jumping-off place for the artist's vision, a point of departure. After all, no two artists will look at the same landscape from the same standpoint; they will have different ideas about it and their vision is more likely to be subjective than objective. As André Lhote said of the pictures of Cézanne, Renoir and Seurat, "It is said that one can walk in their landscapes not with the feet, but with the mind" and the Camden Town Group painter Robert Bevan remarked, "I see the Chilterns quite differently since John Nash began painting them" while, on a lighter note there is Whistler's famous crack, "Nature is catching up on us". At any event, in watercolour, landscape-based painting appears more often than any other theme and indeed in exhibitions landscapes outnumber other themes by about two thirds to one third, with variations on the still-life arrangement also very much to the fore.

For most of the artists under discussion this holds good, and if changes are coming slowly in painting themes it is more as a result of the personal approach of individual artists than of any diminishing of interest in painting some aspect of the visible world. For most painters working here, landscape would seem to be at any rate the usual starting-off point. It is always dangerous however, to try to categorise

painters and painting for the sake of neatness or in order to create an artificial, if convenient, set of labels. Artists are free agents and they can paint whatever excites them; they can also change direction, as we have seen. It would therefore be rash to assume that because any artist happens to be referred to here in the connotation of landscape that such a label is intended to stick. Equally, it is certainly not intended that any of them because of inclusion in an account of watercolour painting, is to be thought of exclusively as a "watercolour artist". This is less of a disclaimer than a gentle warning, made out of a sense of justice to the artists concerned.

A painter's reputation and importance at any time lies only in the quality of his work and in the presence it establishes when exhibited, either in the company of other painters' work or in the context of a one-man show. The public exhibition in Scotland has already been remarked upon for the part it plays in helping to establish such reputations, and it is logical at this stage to consider some of the many painters whose watercolours most frequently set the scene today, not only in the annual exhibitions of the RSW but wherever works in this medium are shown together. A few have been referred to briefly, and others not at all. In attempting to draw attention to those artists whose work gives or has given me most pleasure it is my firm hope that the list will be considered as undefinitive as it will be incomplete. Rating-lists are for, apart from the birds, the world of show-business.

In any mixed exhibition of Scottish watercolours Elizabeth Blackadder will occupy a prominent place with consistent distinction and she has been doing so for about twenty years. Few contemporary Scottish artists have exhibited more widely or received more widespread acclaim. She is one of the two active painters in Scotland who hold membership of the Royal Academy as well as of her native RSA, has exhibited frequently in London and the South as well as abroad and is represented in many international collections. The reason is not far to seek. As a draughtsman she has always been outstandingly gifted. In her painting she has qualities which would have been noteworthy at any time — complete command of her medium and materials, original vision and a constantly developing outlook, never content with the repetition of success. In watercolour she has moved through a variety of landscape-based themes, exhibiting a broad and unworried grasp of the essence of a place, be it Greece or Italy, France or the Island of Harris. Sometimes in her landscapes she has worked within a very restricted palette, with the subtlest chromatic variations showing through here and there. She has a sharp eye for the most economical way of stating only essential shapes in the land mass.

The table-top as a theme has also occupied her extensively. While, basically, the table-top derives from the still-life group of objects set up before the painter in the studio, examples of which can be found right back through all the centuries of Western Painting from Van Eyck's apples on the Arnolfini's window-sill to Jan Fyt's lobsters and white wine or Chardin's miraculous little groups of humble kitchen utensils to the monumental and exploratory banks of fruit and draperies of Cézanne, this theme has undergone just as much change in the present century as any other subject. Probably, through the effect of Cubism on the static object, still-life has seen most change of all. Although it was never the same after Braque's

30. GEORGE MACKIE DFC RDI RSW *Greenhouses at Crathes*
Private Collection

preoccupation with it a long time ago, still-life painting based on the Braque idiom of the almost verticle table-top was still raising eyebrows in the 1950s when Anne Redpath adapted the viewpoint for her own purposes. Since then, however, even bigger changes have occurred. The table-top is now more often a whole painting field in which to float shapes and colours — an atmosphere, rather than a solid foundation for objects. Painting table-top themes is concerned with picture-making within the four sides of the frame, always supposing it has only four sides — frames change, too.

Elizabeth Blackadder's frames, so far, have been limited to four sides, within which she situates many small and sometimes even miniature shapes of trinkets or fragments of brightly coloured ribbon, widely scattered over a large format and causing tensions and correspondences to occur between them through little sparkling notes of colour. She is sensitive with textures and experiments with exotic paper with a textured surface as a painting ground. The table-top owes less to natural appearances than formerly and becomes a vehicle for her inventiveness.

More recently she has worked on portraits occasionally and has also introduced her cats into her paintings — but these are not animal paintings as such. The shape of the cat has also been used in a table-top ensemble to introduce a dynamic feature and sometimes to use the cat's shape decoratively. Elizabeth Blackadder's watercolour technique is assured and can lend itself to expression on a large scale.

David McClure too has moved out of landscape and into the interior of his studio in much of his work, using that as his principal painting theme, although landscape still plays a part in his watercolours. Possessed of a rich and even opulent sense of colour — he is one of the most seductive colourists around — his paintings

71

are as a rule about the hedonistic pleasures of the visible environment, although there was an Italian period some years ago when sinister and richly garbed figures made an appearance, but this seems to be in the past. He has painted his family, his domestic setting and above all his studio interior to form a kind of personal myth, and like Braque he can play endless variations on the studio or still-life theme, with beautiful colour orchestrations built around the familiar props of easels and couches and tables with flowers or musical instruments, with sometimes a nude or bird shapes — pigeons, generally — as the main feature of the composition.

Landscape has been the staple concern of another artist whose compelling watercolours have become inseparable from most major exhibitions in Scotland over the last two decades. John Houston's landscapes started off on the East Coast, with near-monochrome, greyed visions of sea-walls and textured breakwaters as the main subject, then he moved into colour with a confidence and fluency which have developed into one of the most spectacular talents in Scottish painting. At first very much in the soft-focus, fluid colour style of the "Edinburgh School", he quickly established a reputation for enticing harmonies of warm, vibrant reds and yellows, with as his themes flowers or birds in a landscape. A period of dramatic seascapes with figures isolated against long beaches led to the sea itself, and while it is always dangerous to be too precise in describing an artist's artistic pre-occupations, the sea does fill most of his pictures today — or, more accurately, the sea and the sky. A Canadian visit produced some large oils of skies over lakes in which the sky covered almost all of the picture surface and in which beautiful colour had free and expressionistic rein. When he does this in watercolour the result is rivetting. Technically he appears to be completely without limitations and he develops his work constantly, in watercolour getting — incredibly — more and more power and fluency.

Colour dominates everything in the paintings of William Baillie, the current President of the Society, and he too has moved consistently towards a concept which can afford him the maximum opportunities for its exploitation — the interior environment or the table-top, but in the latter case Baillie's table-tops hold suggestions of depth and space. "Suggestions" is an operative word in his case, for he hints at his themes and evokes an atmosphere or a mood by chromatic devices rather than by direct statement of subject. Essentially in the "Edinburgh School" tradition, his seductive, shifting and elusive shapes float in a colour ambience entirely his own, and he can produce time after time, from his studio-based inventiveness, unusual and beautiful justapositions of colour. His watercolour style is liquid, with wet-paper handling and, although he has worked occasionally on a large scale it is in the smaller format of pictures of domestic size that his talents for pictorial organisation and colour orchestration are seen to greatest advantage.

James Robertson's approach to landscape has nothing much to do with topography, although it is created out of a contemplative observation of natural forms. As a rule it is not specific as to locale and his subjects and titles general rather than particularised, with references to the seasons, or an indeterminate physical feature such as *Desert Edge*. On other occasions he will create a landscape theme

31. FRANCES WALKER ARSA *Tormore Quarry*
Private Collection

out of colour-influenced ideas or from a shape or conformation in a scene which he wishes to develop. The picture which eventually emerges is therefore the product of a mental process as well as of the result of looking — Graham Sutherland has done this in his early work in Pembroke, but more often than not he was considering a tiny element in the landscape such as a pebble or small boulder or a gorse bush. Robertson is always figurative, but he uses pictorial devices which have only painting significance — slabs of colour, arbitrary as far as the landscape is concerned but vital in his concept. These act as leads-in to the picture space, or "stops" for the eye or they may be simply put there for a chromatic reason. There is a parellel (although the effect may be different in every way) with the stripes and "medal-ribbon" type of device used by Sir Robin Philipson. The device serves an aesthetic purpose in the context of a mainly figurative picture. The word usually applied to paintings in which the subject passes through the artist's eye into his mind, to emerge transformed in the image he has selected for it is "paraphrasing", and this seems to me to be a satisfactory explanation also of the process. James Robertson is one of Scotland's most individual artists in the sense that he seems not

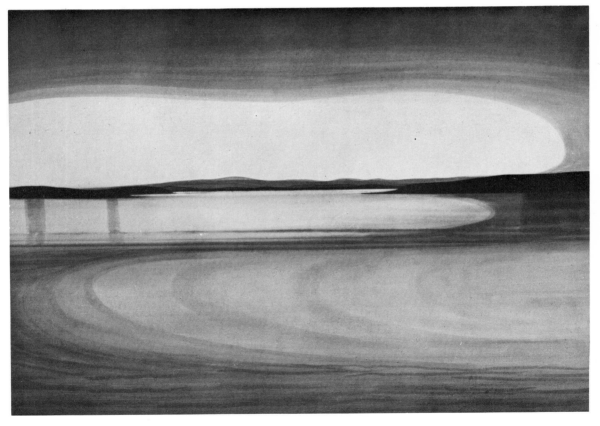

32. BET LOW RSW *After Sunset, Northern Isles 1979*
Collection the Artist

74

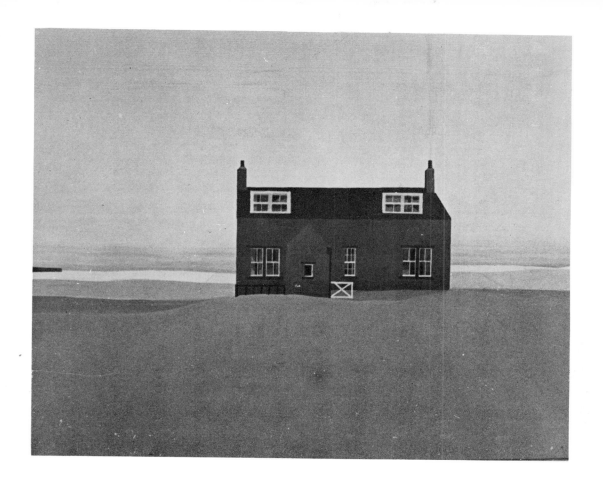

33. JAMES FAIRGRIEVE ARSA RSW *Hill-house, Evening* 23 × 38
Collection the Artist

to derive from other artists or trends, but to do his work with a single-mindedness which is exceptional. In his watercolours he is powerfully expressionistic and uses body-colour vigorously and broadly. Whether on a large scale or a tiny one, certain painters can contrive to impose their presence on a gallery wall so that the viewer is always conscious of it. This does not mean that the work is screaming for attention, or that its colour is blowing bugles at one — it can happen with quiet painting too. When paintings by Alexander Campbell make their appearance their undemonstrative rightness of tone and their gentle and very personal colour harmonies, with their invariable satisfaction of design, cause this effect. Campbell paints soft-edged but with the difference that there is a powerfully controlled design underlying the fluffy perimeters of his shapes. He uses body-colour in a liquid fashion, but although the component parts of his composition may appear to float together, in actuality they are dove-tailed in an interlocking structure which looks inevitable — there was no other way it would have worked better. He is not limited

to any particular type of subject, although recently he has painted some lovely soft-toned harbours and boats in pearly greys, yellowish greys, dusty pinks and black, larger than his usual modest scale and despite their total lack of a strident note they have been unassuming magnets for the eye. Alexander Campbell is a distinguished teacher at Edinburgh College of Art and although a comparative newcomer to watercolour exhibiting he has already made a considerable contribution to the look of the Society's walls.

Barbara Balmer's delicately-balanced and essentially graceful compositions with their clear, unworried colour and eye-catching accents are also among the most distinctive paintings to be found in any exhibition where she is showing her work. They are feminine in the best sense of that dangerous word (in painting) but have of course, as a result of that, a deceptive strength and directness together with a refinement (another dangerous word) which can restore order to any wall where the brushwork is getting too rough. She is an artist who, although no newcomer to painting or to watercolour, has been making a bigger impact in her work in recent years then ever before. She is also well able to handle large-scale paintings, both in oils and watercolour, and they lose nothing of her essentially feather-light touch in the process. Although she paints a wide variety of subjects, including landscape, it is probably in her interiors and what might be termed ''domestic'' subjects that her talents are best seen — the occasional window inside a room, ambitious flower arrangements with furniture and sometimes a stunning portrait. She is one of that small group of Edinburgh painters during her period of training whose work is based on distinct shape-values. Hard-edged, is however, a misleading description for an artist whose control of these edges in respect of colour and tone is so thoughtful.

To continue the celebration of painters whose work is consistently developing and maturing, even after many years of excellence, brings my attention to another lady whose watercolours have been quietly admired in exhibition after exhibition for something like twenty five years and whose quality of painting is seen in recent outings to be even more individualistic and distinctive than before. The classical, rhythmic still-life arrangements of Alison McKenzie have made their unostentatious but telling presence felt through her single-minded application to the basic principles of good picture-making, a determination to ''do her own thing'' regardless of passing fashions and bandwaggons, and a colour-sense which is exactly right for her idiom. She paints a version of Cubism — not the severely formal analytical type but rather the Post-Cubist decorative approach to still-life of Braque in his middle years. If this sounds derivative then of course it has to be so to some extent — after all the inventions of Braque and Picasso in Cubism have passed into the vocabulary of painting and are there to be used. Few people can be unaware of them. What Alison McKenzie does however, is her own personal interpretation and I can't think of anyone else who has done painting of this kind in watercolour. She works in a carefully controlled and simplified structure, two-dimensional in the main, which is probably the result of much re-shaping of her original idea for a particular picture. Her range of colours is restricted to the tertiary browns and variations on dull greens, greys, ochres and blacks which suit the quiet mood and calm of her subjects,

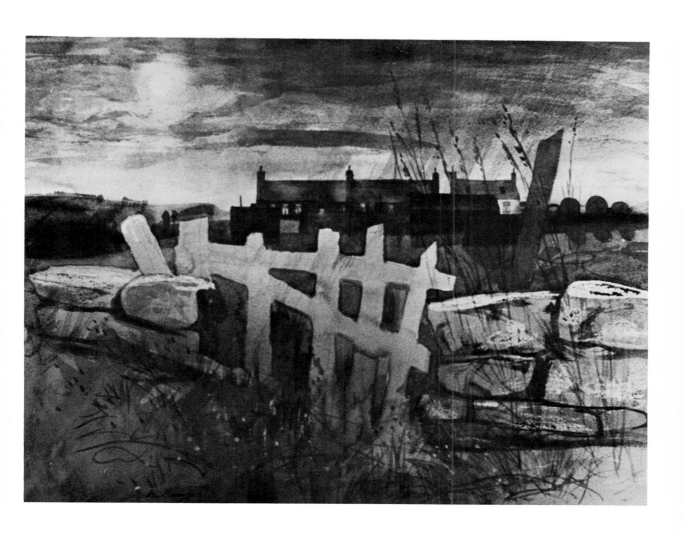

34. IAN FLEMING RSA RSW RWA *Clear Light after Rain*
Lothian Region Schools Picture Collection

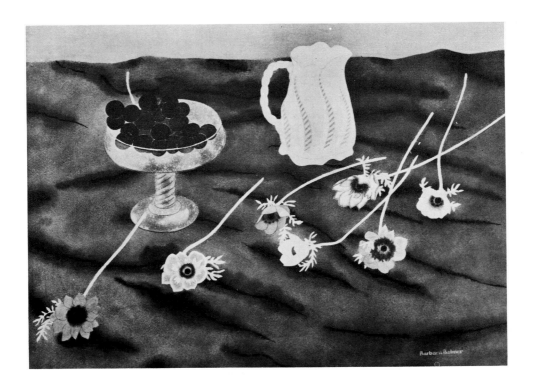

35. BARBARA BALMER ARSA RSW *Diagonal Still Life 1976*
Private Collection

and she has a knowing eye for plant forms which must stem from a real affection for them. She is also another example of a painter who has come to her theme by way of landscape, but the latter makes only the occasional appearance in her recent work. It is not surprising, in view of her fine craftsmanship, to reflect that she at one time carried out ambitious wood-engravings.

George Mackie, widely-respected for his contribution to the graphic arts in Scotland, is also a watercolour exhibitor of long-standing whose modestly-scaled and sensitively drawn paintings of boats and shipping at Aberdeen and elsewhere can, even with their size, send a sparkle of clear, sharp colour across a gallery. His titles are often the names of ships — *Tracker, Actic Seal and King Supplier* comes to mind — and these pictures are as much portraits of the vessels as they are paintings of atmosphere and the feeling of place. But they transcend mere accurate drawing of shipping and have a real feeling of fresh air blowing through them. His meticulous and intimate draughtsmanship in watercolour is also frequently applied to landscapes at home and, occasionally, abroad.

George Johnston, from Dundee, extracts a certain pathos but also a glowing vision of rich colour from the unpromising desolation of slum tenements and urban streets in many of his best paintings, and although this is not his exclusive subject-matter it is in this rich vein—explored also by Henderson Blyth, Eardley and James Morrison in the past—that he has become well known.

Economy of means is a quality which accords with the watercolour medium when it is at its purest, and there cannot be many examples of "pure" watercolour where the ends are achieved with such minimal use of flourish or bravura as is employed by Bet Low. Here is yet another painter of steady devotion to a personal idiom who has been maturing in her work year by year. Her landscapes — or more often, "land-and-water-scapes", because she depends greatly on the calm lines and static shapes which a mass of water in a loch or kyle can provide, make their still presence felt among any company of paintings. The label "minimal art" normally applies to non-representational, large-scale paintings in which the surface is disturbed only enough to indicate that someone has been working on it, usually round the edges, but when the term is applied to Bet Low's carefully designed pictures the implication is very different — a great deal of work underlies the honed and polished end-product. She derives from no one, but in her astringent yet gentle paintings there is a reduction to essentials which runs parallel to Milton Avery's watercolours in the States.

Bill Wright's paintings of sea-shore tracks and tidelines and wave patterns in the sand and the constant though sometimes unseen presence of bird life also depend on creating surfaces uncluttered by extraneous shapes, but there is nothing "minimal" about them. These are deeply meditational paintings, with beautiful textural effects and soft, enticing colours which, wherever they appear, call for contemplation and thought. They contain an ecological message as well as appealing to the senses. To be in tune with the starker aspects of nature means to avoid like the plague anything approaching the picturesque or the grandiose, and the essence of this approach lies in the grave, still paintings of Berwickshire winters which James Fairgrieve can produce. Snow transforms the landscape and, as we all know, recreates it in a different pictorial language from the landscapes of high summer or early spring. There is a total lack of the felicitous, and the taut designs of fences against unbroken tracts of ground and the isolation of lonely hill farms are expressed only after the most stringent selection of essentials. Fairgrieve's pictures stem from his early days in the 57 Group and he can make one acutely aware of minute detail too — the kind of detail which one so often observes but never stops to think about, like the way a single strand of fence wire can change from a silhouette to a reflection as the sun strikes it. Sometimes his deliberately empty spaces of land or sky exist pictorially only because of the tensions he creates in the manipulation of the design, and as a superb draughtsman, he knows how to make every shape tell.

Gordon Bryce has been exploring this kind of subject-matter or late, after his freer, softer-edged style of some years ago. He is a talented artist in either oils or watercolour but his recent essays in the latter medium have achieved new heights of accomplishment in the sweep and significance of his shapes. The parenthetical form

of a copse against the snow, or the horizontal layering of snow-covered rock-faces are always related to the forms of his skies, so that an order of events spreads across the whole picture surface. Again, there is a beautiful stillness in some of his atmospheric mountain-top scenes, but the picture is always built on a dynamic design structure.

Starkness of another kind, with a total exclusion of "painterliness" of even of any suggestion of personal handwriting in the application of the brush, is a trend in much of the painting of today. The origins probably lie in Surrealism, in which there has been a revival of interest in Scottish painting. This is not the Surrealism of Ernst or Dali but rather of René Magritte, in which a dead-pan, almost photographic type of realism cloaks disquieting events in everyday images. The effect plays on the spectator's mind and imagination. In films, Hitchcock does it by inserting a strange occurrence in a banal setting and one feels the strangeness the more powerfully. "That could be happening in *our* street!" To do this in painting, and more especially in watercolour demands an immaculate technique and qualities of draughtsmanship of a high order. David Evans has both attributes and possesses the turn of imagination to make it work. He can cause havoc by painting a roomful of empty chairs. Some of his imagery is American — gas-stations and the brassy glare of drab highways — and contains something of that dread which such scenes can generate; the feeling of man's vulnerability in the civilised jungle. There is a starkness also in Kirkland Main's beautifully composed paintings, but it is only in the subject-matter

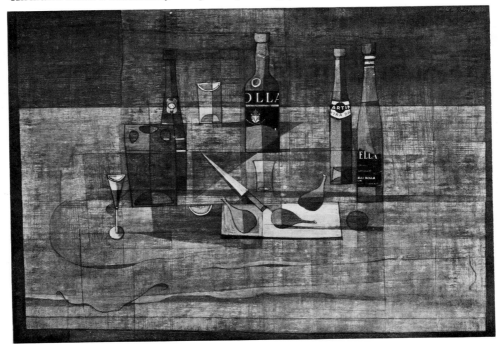

36. CARLO ROSSI RSW *Divertimento*
Collection the Artist

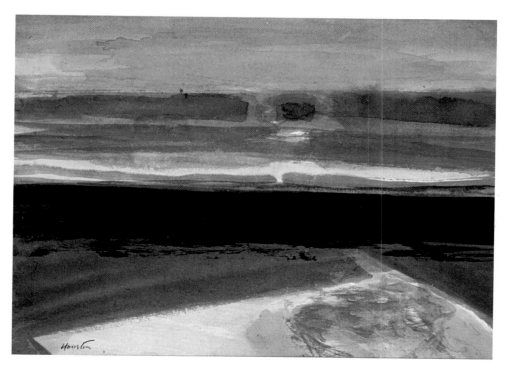

12. JOHN HOUSTON RSA RSW *Sunset over the Beach* 16 × 20
Private Collection

13. BILL WRIGHT RSW *Nervous Shorebird* 30½ × 22½
Private Collection

14. WILLIAM BAILLIE ARSA PRSW *Garden Table* 12 × 16
Lothian Region Schools Picture Collection

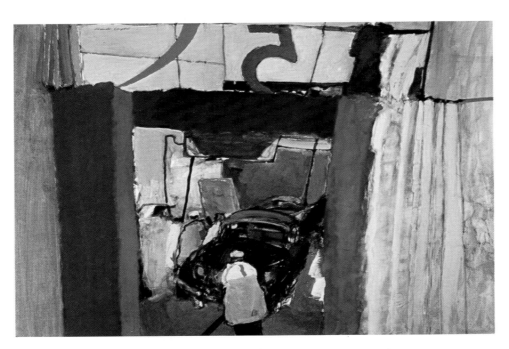

15. ALEXANDER CAMPBELL ARSA RSW *Five Minute Car Wash* 30 × 40
Lothian Region Schools Picture Collection

37. **WILLIAM LITTLEJOHN RSA RSW** *Fish at a Harbour* 17½ × 28
Collection the Artist

as a rule — mysterious excavations and concrete structures in unexplained surroundings which turn out to be an archaeological ''dig'' in progress or a building operation. The strangeness, in fact, is in the eye of the beholder. But Main is a sensitive watercolour painter with a limpid colour-sense which accords very well with his precise drawing and clean-cut, arresting style.

Although a great deal of the painting under discussion is landscape-based, the enormous variety of attitudes and approaches to the subject among contemporary watercolour artists in Scotland ensures that there is no possible danger of monotony, even in a large exhibition, but it is always interesting to come across painters whose preferences lie in totally different directions. Figure painting as an almost exclusive theme is rare in watercolour, but Anda Paterson's graceful arabesques of Spanish or Italian peasants, essentially conceived as decoration, create another type of focal

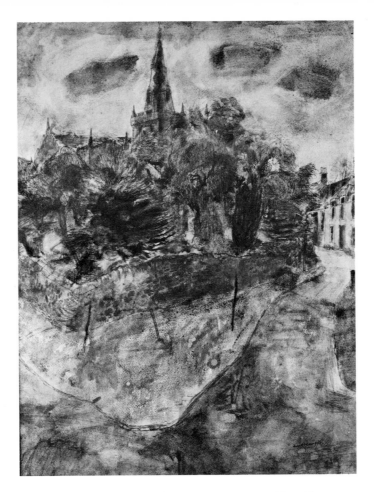

38. JOHN B. FLEMING RSW *Kirk at Upper Largo* 28 × 18
Private Collection

point on an exhibition wall. They are both conscious of the stresses of labour or poverty and at the same time beautifully designed objects in their own right, often unusual in scale or format. Right out of the run-of-the-mill also are the brilliant, bejewelled little jungles with peeping tigers and other gorgeous fauna which have recently sprinkled their bright colours over exhibitions and which are the special and much admired contributions of Anthea Lewis. James A. M. Dickson paints a theme which is so unlikely as a vehicle for watercolour that nobody else has attempted it. He concentrates on the unpromising subject of old railway stock, and out of rusted metal and the forms of locomotive engineering standing amid that appalling type of wasteland which is the average deserted siding, contrives to paint pictures with sensibility and considerable painting quality. What was the beginning of that compliment paid by Sickert to Gore, again? "He has the digestion of an ostrich!" Dickson's paintings are always interesting.

Among mature talents who have sustained and added to the impetus there are such as William Littlejohn who has brought his dream-like personal vision and

enchanting colour to the medium; Derek Clarke, who has turned his draughtsmanly skills to watercolour landscape in increasing measure; Alexander Fraser with his coinage of a different vocabulary of subtle and expressive symbols for the everyday event, coupled with real pictorial qualities of shape and colour; Ian Short, who carries on the devotion of the late William Burns to the seatowns of the North East, using something of Burns' rich red scheme but with his own emphasis on the actual buildings rather than the paraphernalia of the harbour; William Birnie in his richly Impressionistic landscapes, and the vigorous and daring talents of Danny Ferguson and George Devlin, each of whom in his own different way can create images of power and weight.

Then there is Robert Leishman, an artist of fantasy and no other theme. Like others mentioned here he has been known for many years for his dark visions of flowers at night, enchanted forests, dazzling birds, angels and a host of other inhabitants of his pictorial trances. Some of the elements might be found in John Maxwell on occasions, but only in the sense that fantasy often concerns the same themes and manifestations. The scintillating colour and the bewitched mood are Leishman's and nobody else's.

There are yet more mature and distinctive artists whose work, in quite disparate ways, is again involved with the endless attraction of the sky and the land. Edward Gage's fluent and opulently painted pictures are full of the warmth and light of the

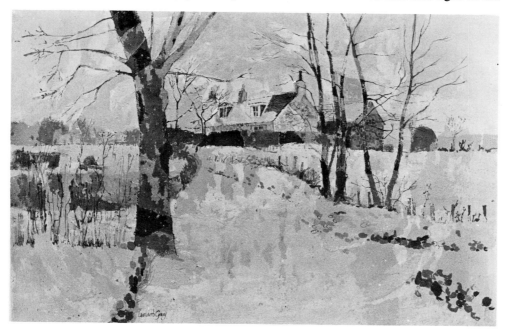

39. LEONARD GRAY RSW *Winter, Old North Deeside Road, Bieldside* 21 × 28
Collection the Artist

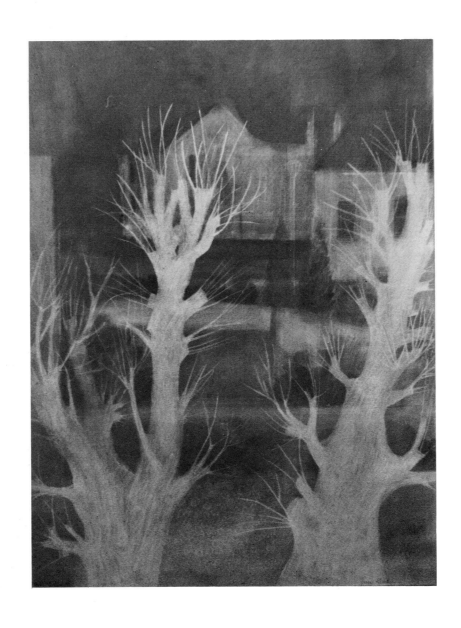

40. JOAN RENTON RSW *Trinity at Night* 30½ × 22
Collection the Artist

84

Midi or the lands of the Mediterranean and create colour harmonies and eye-catching, simplified designs. He is essentially of the "Edinburgh School" with its soft-edged masses and liquid, flowing watercolour technique and yet, as befits a skilled draughtsman, everything is subject to his own order. They are pictures clearly painted with enjoyment and intended to give it also.

Mardi Barrie paints prolifically in oils and watercolour and — again in a soft-focus idiom — simplifies and reduces the shapes of her landscapes to a point where they teeter on the brink of abstraction but never lose their original identity. She works in terms of large, pliant masses, painted broadly and sweepingly and this style creates its own rhythmic division of the picture surface. One feels that the action of painting has in itself brought about the design of the picture, rather than that she has proceeded to organise from a clear-cut preconception. But these are not abstract pictures and they have an indefinable sense of place and an atmospheric quality which suggests light and space.

James Morrison has been a landscape painter, unavowedly, most of his painting life, and with the passage of time his vision has crystallised more and more until recently he has brought an almost photographic clarity to his sharp realism. This is in contrast to the process which some painters pursue, in which their work loosens up and broadens as they continue. Morrison began in a softer manner than he presently employs and now he attempts — with great skill — to paint complex tangles of trees and vegetation with almost hallucinatory emphasis, very often on a large scale, yet in a sense, despite the size of many of his pictures, he is painting a microcosmic view of nature and doing so to considerable effect.

Newcomers to the ranks of the Society — some of whom are painters of reputation and experience — have in recent years included Carlo Rossi, Joan Renton, Donald Buyers, Marjorie Stark, John Mitchell, Ian Cook, Brian Keany, Frank Docherty, George Gilbert, Alfons Jasinski and Richard Hunter as well as several others previously mentioned. Rossi's carefully structured and glowing table-top arrangements have added their metaphysical image and musical references to the scene, to bring an entirely different presence to exhibitions. Joan Renton's sweeping, broadly-painted and restrained landscapes have a quiet strength and a distinctive, pale colour key which carries its own impact, no less telling for its reticence of colour, although she often paints vibrant flower subjects as well. Marjorie Stark and Donald Buyers have styles which are becoming well-known in the Society — the former with softly brushed and dreamy Venetian façades and canals, elegant and sensitively felt, while Buyers' landscapes in autumnal colour have recently contained a new note of interest in the shapes and patterns of large foreground moths or butterflies. Jasinski's pictures have recently been concerned with the unfamiliar in fishing or harbour impedimenta, seen in isolation and strangeness.

Lastly in this particular section, as a painter who would not wish to be categorised as a watercolour specialist but who nevertheless brings to this medium all the punch, wit, dead-shot drawing and verve which distinguishes all his work,

Bob Callender makes infrequent but eventful forays into watercolour and each time puts another notch on his gun. He is a most serious artist who appears not to take himself too seriously, which is a pleasant change, and his ability to introduce a slightly satirical humour into his titles is refreshingly different and welcome.

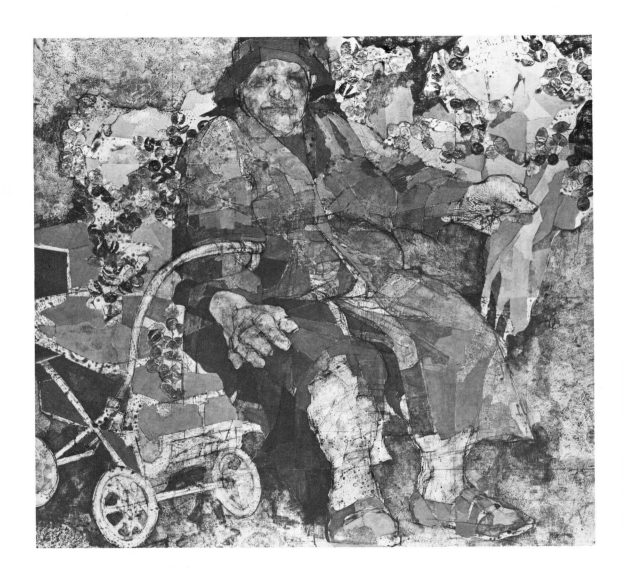

41. ANDA PATERSON RSW RGI *The Flower Seller* 40 × 40
Collection Thomas Boorman, Esq. Sweden

10

Backwards and Forward

IT seems only yesterday that artists were beginning to question the future and even the validity of watercolour societies. Perhaps, people said, they have served their purpose — to give this medium a chance in the weightier world of oil painting. That world had undergone such cataclysmic changes over the years that it seemed to have left watercolour so far behind as to put it in some danger of obsolescence. Modern painting had outgrown many gallery walls in its scale, had involved many different mixtures of media and generally seemed to be bearing less and less resemblance to its traditional appearance. For a while, the international emphasis was non-representational, and the huge environmental paintings of the abstract-expressionists and the minimalists seemed to push watercolour further and further behind in present-day importance.

Then too, there were the other questions relating to the nature of painters' materials. There was a feeling among artists that if you were a painter that was that. Why have a special category for watercolour? What was needed was really good painting. What was a watercolour anyhow? Other water-based materials had appeared — acrylics and polymers and thick, impastoed gouache, and the traditionalists in watercolour societies tended to frown on those. Young painters in their early years were wont to regard watercolour in the same way they regarded the game of bowls. They were not that age yet! So by and large the membership of the Royal Scottish Society of Painters in Water-Colours inclined to be middle-aged, to put it at its gentlest, and its jealously guarded selectivity was formidable.

There is a very different situation today, and no one asks the question — "Why watercolour?" — any more. There are several explanations for the change of attitude and perhaps it is of interest to examine one or two of them.

First of all, the emphasis in painting itself, especially in Britain, has shifted from non-representational work to the observed world, and figuration is back (it was never very far away, but the media can be persuasive). This brings watercolour nearer to the mainstream of painting than before. Also, we had forgotten, or possibly were not sufficiently aware of watercolour to know, that there have been some really great artists in this medium this century whose work lacks for nothing in terms of making a pictorial impact. Watercolours by Rouault and Kokoschka and Nolde and Klee, by the Americans John Marin, Charles Burchfield, Morris Graves, Ben Shahn and Andrew Wyeth could hold their own by any standards of power and profundity. So also could the British watercolour heroes like the brothers Paul and John Nash, Edward Bawden, John Piper, Vivian Pitchforth, Frances Hodgkins (not actually British, but painting here), Graham Sutherland and Edward Burra, with Anthony Gross, William Scott and Patrick Heron for good measure. Watercolour

could never become a quiet back-alley of painting with a body of work of this importance to its credit.

What about Scottish watercolour? When one has examined it over the course of its history and especially over the last thirty years of accelerating productivity and development; after all the exciting and individualistic artists have been considered, all the countless exhibitions remembered and the vitality and achievement of the painting pondered—the question arises, "How does it rate?"

It has always been next to impossible to assess objectively the art of one's own time in the context of the achievements of the past or in relation to the concept of greatness. So many have tried and failed! In the field of art criticism there is a phenomenon known as "The Van Gogh Syndrome". This means simply that a great many critics and writers on art, when confronted by an outstandingly different and original work, shy like a horse which suddenly comes across an eight-foot cobra lying in the path of its morning canter. The graveyards of art criticism are filled with the defunct reputations of writers who failed to recognise outstanding talents at the time of first seeing them. The deficiency is not, of course, peculiar to writers alone—no one is immune from artistic tunnel-vision. It is almost possible to hear the ghostly laughter of the crowds standing in front of Manet's *Le déjeuner sur l'herbe* at its début, or the braying noises at a celebrated Royal Academy banquet many years ago when its President boasted that if Picasso walked in he would kick him in the pants! As Ben Shahn once remarked in his Charles Eliot Norton lectures in the

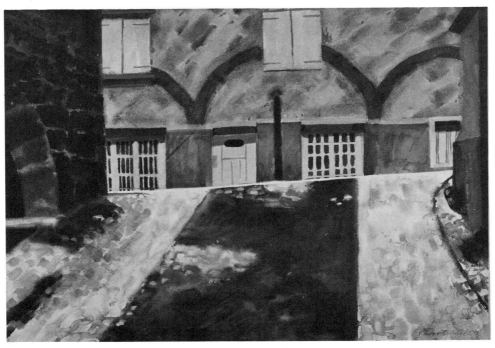

42. **EDWARD GAGE RSW** *Street in Le Puy 1979* **22 × 30**
Collection the Artist

88

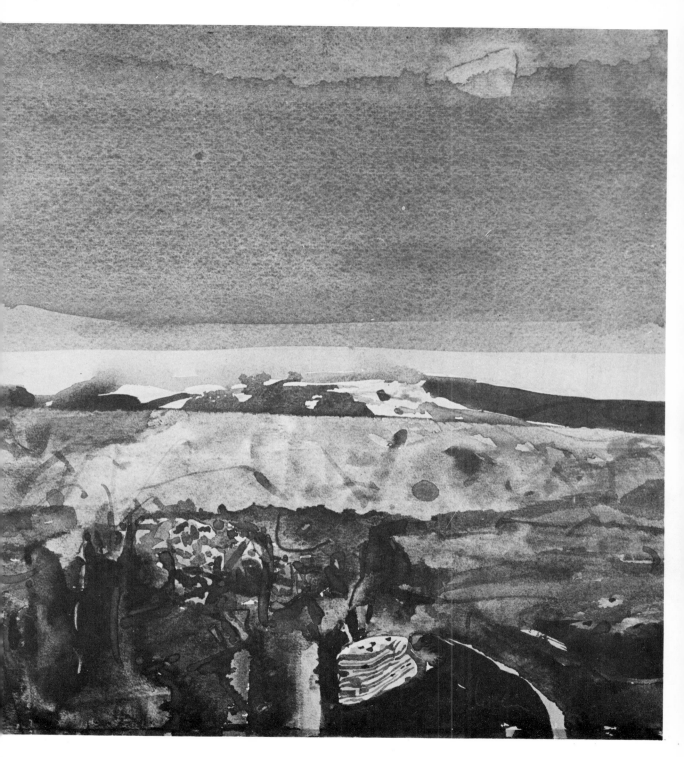

GEORGE DEVLIN RSW *Border Landscape* 13 × 14
Collection Miss P. Finlay

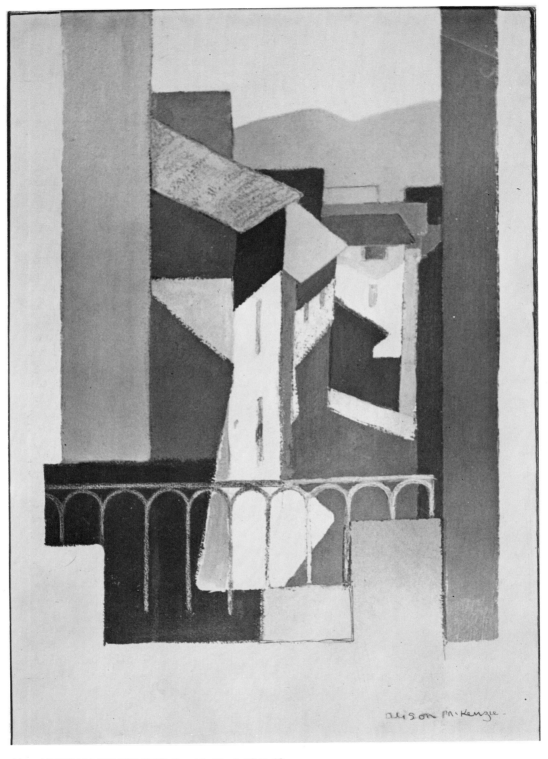

44. ALISON McKENZIE RSW *Street in Tessia* 13 × 19
Collection the Artist

1950s, in the first twenty five years of this century the twenty five annual awards of the Prix de Rome at the Salon des Independents included only Georges Rouault among known names. They had not included Cézanne, Monet, Degas, Derain, Matisse, Utrillo, Picasso, Braque, Leger and the other great artists of the period.

One remembers the name of Louis Vauxcelles, not for his critical articles in *Gil Blas,* but because he gets into the history books only as the man who, in derision, coined the expressions "Wild Beasts" and "Cubism" for the two greatest movements of twentieth century art. There must also be a certain sympathy, however hardly won, for all the museum officials and others who feel compelled to use public funds to purchase or to promote the art of the Emperor's New Clothes lest they should be thought to be "square". It is all very tricky, and there sometimes seems to be a shortage of weights and measures.

So how then, *do* Scottish watercolour artists rate? In his 1943 essays on *Modern Scottish Painting* John Duncan Fergusson recalled his family lawyer saying to him, on hearing of his intention to settle in France, "So your'e going to become a Frenchman?" Fergusson's reply was "No, I hope I'm going to be able to persist in being a Scotsman." Is there something essentially Scottish in our watercolour painting, or in any of our art forms? I am not yet sure that chauvinism is a luxury we can afford to savour where our painting is concerned, but as a nation we are not over-given to it in the context of the arts. Usually we err on the side of modesty, which is perhaps a curious comment about a country whose chauvinism can sometimes be an embarrassment, especially in the uncertain areas of national politics or sport, in both of which we have been known to be vociferous. A traditional lack of published writing about the arts in Scotland has not helped any—we have kept thinking that our painters cannot really be as good as all those prestigious foreigners who have coffee-table monographs produced on their painting. A few such books on some of the important Scottish artists of the last hundred years might have made a huge difference to our national standing in the arts. It is very long time since Sir James Caw and David Martin were writing about McTaggart and the Glasgow School, and the excellent books on the Scottish Colourists were produced in conditions of post-war austerity and economic stingency.

When we think of the mastery of McTaggart, Henry, Crawhall, Rennie Mackintosh, Melville, MacGregor, Pringle, Peploe, Hunter, Cadell and Fergusson, or the whole phenomenon of the Glasgow Style of design in the 1890s, the fine Scottish books in Art Nouveau idiom and the more recent achievements of some of the watercolour artists I have written about at length, or of Joan Eardley—not by any stretch of imagination a watercolour artist in her principal mode of expression but undeniably one of the most powerful painting talents in twentieth century British art—something becomes clear. These are not isolated talents but peaks in a continuous mountain range. Mackintosh, about whom at long last the right kind of books have been written in recent years, can be seen in all his genius as part of a huge artistic movement of the time—"The Glasgow Style" is a fact.

There have been unsolicited testimonials, too, from high places. In his *Three Scottish Colourists* of 1950, the late Dr. Tom Honeyman recalled Dunoyer de

45. BET LOW RSW *Cliffs and Beach*
Collection the Artist

Segonzac saying to him, "You are a funny people, you English." (Honeyman pointed out that de Segonzac meant "Scots"!) "Hunter is one of your great painters and nobody knows anything about him." There was also the often-quoted remark of Oskar Kokoschka to the late Dr. Stanley Cursiter when the latter was Director of the National Galleries of Scotland, and when on seeing MacGregor's *The Vegetable Stall* for the first time, the great Czech painter said, "To think that picture was painted before I was born and I never knew!"

I believe it helps in assessing the present-day Scottish watercolour "school" if they are regarded as part of this continuing movement, and particularly if the momentum and intensity of the movement at the present time are recognized. The climate is much better than it has ever been for Scottish painting. Scottish artists show their work outside of Scotland and many are well known in London; a few more books have appeared; the Edinburgh Festival has spotlighted Scottish artists in a way no one thirty years ago, when Fergusson and Honeyman and Cursiter were writing, could have conceived; the exhibition scene in Scotland has mushroomed and there is an awareness of painting on a scale that does not occur elsewhere outside of the vastness of the metropolitan art world of London. Lastly, as the work of Scottish painters of the past and recent past appreciates in the market-place, more and more attention is focussed on Scottish art today. In consequence, contemporary artists have a confidence in their work which I would put at the top of my list of characteristics.

Earlier I referred to the Scottish use of watercolour to express ideas and themes through modes of espression normally associated with major oil painting, and this, together with a committed twentieth century approach in watercolour, seems to me to be of immense significance. No one with respect for the major masters of watercolour in England—during the 'thirties and the War and Post War years when the Nashes, Sutherland, Bawden, Ravilious and Piper were at their peak—would claim that this propensity is unique, but I would have no hesitation in believing that for it to happen on the scale and with the consistency that occur in Scotland at the moment it constitutes one of those painting "movements" which will come to be talked about in future years. That this has happened in a generation is even more remarkable. I cannot think that it has happened in this way elsewhere. It calls for some sort of celebration.

As this is written—and coincidentally—the Royal Scottish Society of Painters in Water-Colours is about to hold the hundredth exhibition of its members' work. It is immensely heartening to realise that watercolour in Scotland has never been better or more vital than at the present time, nor has it been produced before in such a concentration of ability. Perhaps the most encouraging aspect of all this is the increase in the numbers of young artists who are using the medium, many of whom are exhibiting regularly with effect. It is also good to see painters of repute who have decided to involve themselves more in watercolour.

Complacency is dangerous, but the body of evidence which the painters themselves have amassed through the range and quality of their work would indicate that Scottish watercolour painting has arrived.

Index of British Artists Mentioned in the Text